JAPANESE ACCENTS
IN WESTERN INTERIORS

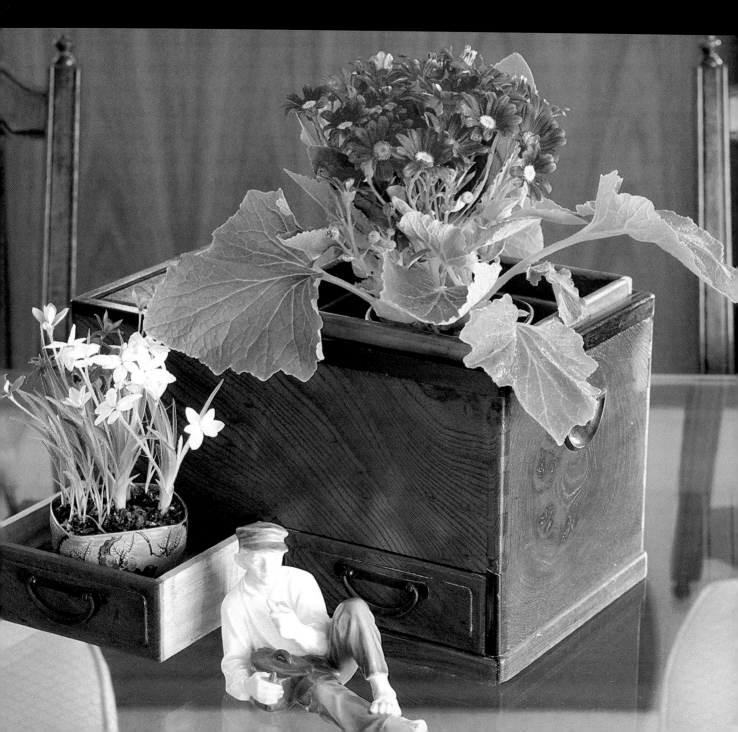

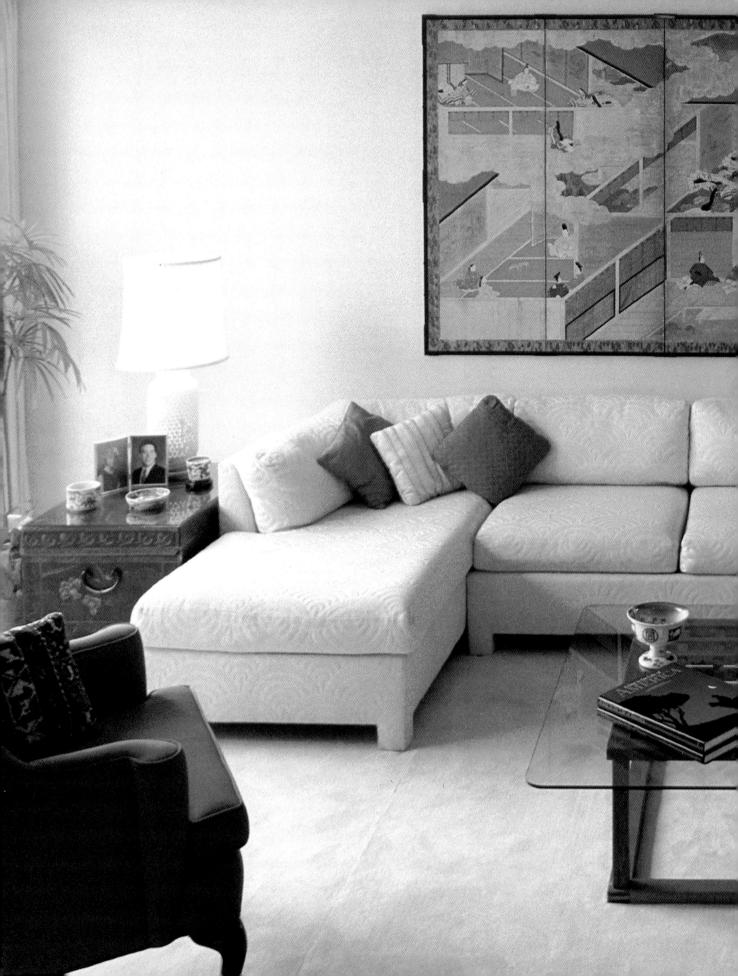

Japanese Accents

IN WESTERN INTERIORS

PEGGY LANDERS RAO **JEAN MAHONEY**

PHOTOGRAPHS BY TOSHIAKI SAKUMA

SHUFUNOTOMO/JAPAN PUBLICATIONS

*To Blanche and Jean Colleran,
each a wellspring
of love and support*

*To Patsy Landers,
who opened doors
to so many beautiful worlds*

Art direction and Book Design by Jean Mahoney

Calligraphy by Momoyo Nishimura

Additional Photo Credits
Jean Mahoney: Pages 4, 5, 49, 55, 63, 101, 105
Peggy Rao: Page 135
Masayoshi Yano: Page 151
Shufunotomo: Pages 23, 31, 39, 95, 115, 145, 151

© Copyright 1988, 1997 in Japan
by Peggy Landers Rao and Jean Mahoney

First paperback edition, 1997
Third printing: April 2001

Published by Shufunotomo Co., Ltd.
2-9, Kanda Surugadai, Chiyoda-ku, Tokyo, 101-8911 Japan

Distributors:
United States: Kodansha America, Inc., through Oxford
University Press, 198 Madison Avenue, New York, NY 10016.
Canada: Fitzhenry & Whiteside Ltd., 195 Allstate Parkway,
Markham, Ontario L3R 4T8.
United Kingdom and Europe: Premier Book Marketing Ltd.,
Clarendon House, 52, Cornmarket Street, Oxford OX1 3HJ.
Australia and New Zealand: Bookwise International, 54
Crittenden Road, Findon, South Australia 5023.
The Far East and Japan: Japan Publications Trading Co., Ltd.,
1-2-1, Sarugaku-cho, Chiyoda-ku, Tokyo, 101-0064 Japan.

Printed in Japan

ISBN: 0-87040-988-3

NOTE: In the Japanese language, nouns do not
change their form to indicate plurals. Therefore,
when using a Japanese word in this book, we
have retained its unvarying form in both singular
and plural contexts.

CONTENTS

Foreword

Oh, East is East and West is West, and never the twain shall meet,
Till Earth and Sky stand presently at God's great Judgment Seat;
But there is neither East nor West, Border, nor Breed nor Birth,
When two strong men stand face to face, though they come from the ends of earth!
—Rudyard Kipling, 1899

Rudyard Kipling's first line is known by all, but most remember only the antagonism: "never the twain shall meet."

A truly good person, kind-hearted and of gentle disposition, will not suffer problems of adaptation while living in Japan. From childhood on, the Japanese are taught to observe a myriad of details. This fosters in their hearts an intuitive knowledge, and when they detect in the foreigner a *yasashii hito*, a gentle-hearted person, the ice soon breaks and problems melt away.

No one is all that perfect though, and we soon realize that quite a bit of patient energy is needed in the process of adaptation to this new culture. Enculturation does not consist of the simplistic attempt of copying as many new habits as possible. Real enculturation goes much deeper. It must take roots in one's "being," rather than one's "doing."

We need not soak in a hot *furo* to feel happily immersed in the culture; nor go to sleep on *tatami* with the wishful dream: "I am adapted!" Continuing down that avenue results in a bad case of identity crisis.

While discovering Japanese ways and observing their many sparkling facets, we cannot help but reflect upon our own culture and become aware of its limitations. Any culture is a limited expression of the total human reality. We also discover the positive values of our own cultures. These we must treasure. The secret to contentment in another land is not to compare, but to observe the many differences and then incorporate. We must cherish our own identities, while absorbing the many positive human elements of the culture around us.

In a way, *Japanese Accents* is about one aspect of enculturation. Jean Mahoney and Peggy Rao were intrigued by the way people of various nationalities created a warm and comfortable "home away from home." The Tokyo residents in this book have successfully mixed what they enjoy—whether it is Oriental, American, Australian or European—and have come to cherish the adopted accents with their own. What was once foreign becomes familiar.

Their adaptation is exemplified in many different ways on these pages, from the children who take great delight in arranging the *hashi oki* on display to the hostess who replaces a floral centerpiece with a line of *soba* cups for her guests to admire. There is the artist who views a piece of handwoven fabric as a work of art in itself. And the family that prizes a humble work garment with its minuscule stitches and displays it on the living room wall for everyone to enjoy. The sense of warmth and beauty in these homes transcends nationality.

Granted, all these acquisitions are but material things in an ephemeral world. However, if one's focus does not stay with the objects, but allows them to serve as a reminder of minds enriched by the privilege of living abroad, then the twain have met and merged resoundingly.

Joseph R. De Roo
Institute of Japanese Studies
Tokyo, 1988

Introduction

Initial visits to Tokyo's antique stores and open markets can be overwhelming. The shopper lingers over a fine antique and says, "It's lovely, but what is it and where can I put it in my home?"

Or the visitor purchases an inviting piece of folkcraft—generally, a more impulsive buy than an antique—and discovers it looks out of place in a Western home.

Gradually, a newcomer to shopping in Japan realizes that an intriguing piece can often be incorporated into a Western lifestyle by asking it to play a role completely different from its original function. A *hibachi* becomes a planter, an obi appears on a party table, and chopstick rests turn into place cards.

As our circle of friends grew in Tokyo, we became fascinated by all the different ways creative Westerners add Japan's treasures to their lives. Some uses are imaginative, some ingenious, and some positively inspired. We've included a wide cross-section in this photographic visit to actual Tokyo homes.

In general, our criteria for selection was that the use had to be inventive. For example, we have not focused on *tansu*, since a chest tends to be a chest in any lifestyle. However, when a staircase chest is positioned imaginatively in a Western interior, we do show you that use.

While shopping in Japan, one also becomes aware that the categories for artistic selection are broad. "Craft" in Japan does not mean "tourist item" as it does in so many nations. More precisely, it means *mingei*, a special word coined in the 1920's by Sōetsu Yanagi describing the work of the unknown craftsman. *Mingei* means utilitarian objects with an artistic appeal. Fine art, Yanagi said, is made by the few for the few. Folk craft is made by the many for the many.

John Lowe points out in *Japanese Crafts*, "In Japan, no hard line is drawn between artists and craftsmen. The Japanese artist is first a craftsman, and the greatest Japanese artists have never hesitated to decorate humble craft objects."

Lowe goes on to say that "part of the fascination of Japan's civilization is how from earliest times such a subtle and beautiful culture has been created through the infinite exploitation of simplicity. Japan has always been poor in native raw materials. Yet an amazingly complex art, architecture and way of life have been created from bamboo, clay, paper, rice and a few other humble, indigenous materials."

Because of this richness, Japan offers a unique opportunity to appreciate new arts and crafts at every turn. We hope that this book helps orient readers to make useful acquisitions and inspires the creation of one's own East-West aesthetics. Our background explanations are intended to serve as an introductory overview, which may help the reader discover areas to pursue in depth. Each of the topics discussed in this book is the subject of many excellent books available in English.

In making good our two goals of showing how to incorporate Japanese objects and of explaining their original functions, we learned a great deal about Japan's cultural heritage. Some of the answers, however, were not always readily available. Very often, it was only the senior members of the Japanese community who could give us precise details. We mention this to suggest that the opportunity to acquire some artistic artifacts of Japan's heritage is of limited duration as certain objects disappear from use in modern Japan.

We hope that these pages prompt you to take a closer look at the fine pieces of Japanese craftsmanship that are still available. It is hard not to be attracted by their charm, the attention to detail

and the colorful traditions that they represent. If you are Japanese, we hope that you will continue to prize the uniqueness and quality found in your everyday things and preserve the rich traditions of your culture.

We are grateful to a number of individuals who played important roles in the production of this book: Toshiaki Sakuma, whose photographic skill and artistic sensibility taught us that language is not a barrier; Shun-ichi Kamiya, our editor at Shufunotomo, whose guidance and constant good nature made this book a pleasure to create; Patricia Massy, Nancy Russell, Angelia Huse and Kimiyo Endo for technical consultation; the Jantos family for computer advice and sympathy; the many antique dealers who graciously fielded questions; and our own families who good-naturedly endured the neglect of our own houses while this project was underway.

But most of all, we give our special thanks to all the dynamic individuals of many nations, who opened their homes to us and whose enthusiasm for this project made it possible.

Peggy Landers Rao
Jean Mahoney
Tokyo, 1988

Hibachi

A wooden Kansai style *hibachi* and two ceramic ones assume modern roles in this demonstration of Susan Paul Geffen's masterful eclectism. She designed their Tokyo living room as a showcase for their international art collection. A neutral palette accentuates rather than competes with the paintings, which are changed frequently to give the room continual interest. The Persian carpet is an Isfahan design.

Too lovely to disappear, *hibachi* are rising phoenix-like from their ashes to play other roles in Western interiors.

To many people, "hibachi" suggests the small table-top grills of the Western world. In Japan, it is something quite different: a finely crafted brazier used in old homes and shops to provide heat, warm saké and boil water for tea. This portable fireplace was also the emotional center of the home, since family and friends gathered round its welcoming warmth.

Many families made it a tradition to keep the fire burning continuously. In the late 19th century, one Tokyo family was reputed to have kept a fire alive for two hundred years. Actually, a fire in summer was a good antidote for the city's high humidity.

Today, active *hibachi* smolder only in an occasional house. The rest, having found their way into antique stores, proliferate in Western homes, where they are prized for their craftsmanship and utilized in imaginative ways very different from their original purpose.

WOODEN HIBACHI

The very earliest *hibachi* date to the Heian era (794–1185) and were round metal pans set in lacquered cypress trays with graceful curved legs. For centuries they were the exclusive property of the imperial court, the feudal lords and later, the shoguns.

In the 17th century when charcoal became readily available, "hibachi" became a household word. Great care was lavished on its creation, since it was the focal point of the home. These *hibachi* had copper ash receptacles positioned in low wooden boxes. The tea kettle sat on a three-legged metal trivet over the charcoal fire.

The supporting boxes were made of either zelkova (*keyaki*) or paulownia (*kiri*) wood, both prized for their resistance to expansion and contraction. Many had small drawers on one side for tobacco, eyeglasses or writing materials. The head of the house would take his seat on the *tatami* in front of the drawers, but the opposite side was also finely finished since it faced the guests.

Zelkova, a member of the elm family, has a bold grain and

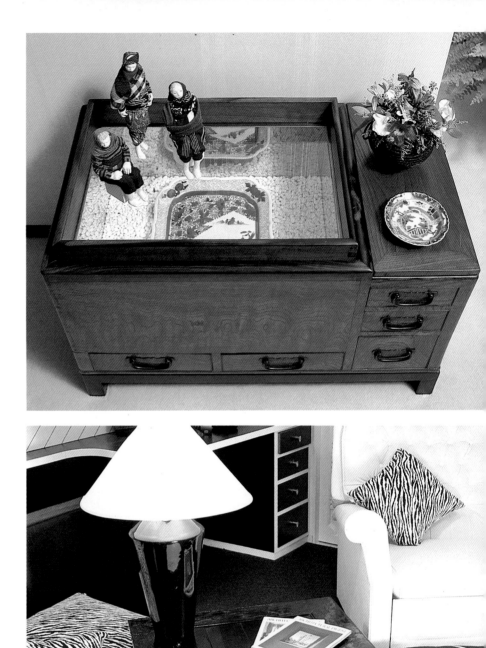

TOP: The *hibachi's* gleaming copper ash receptacle makes an ideal display box. Barbara and Pieter Ruig's 100-year-old Kanto design *hibachi* is enhanced by a prize piece of antique Imari resting on white pebbles. Mrs. Ruig had new copper placed over the old to preserve its authenticity. A sheet of glass makes it an end table for the display of handmade dolls.

ABOVE: Joan Shepherd rescued this *hibachi* from a trash pile during her early days in Japan many years ago. She painted the chipped red lacquer black, and it is still a vital part of her office decor. The ash box is covered by the original planks that regulated the heat.

OPPOSITE: An upstairs guest room yields a collection of sea shells, displayed in a Kansai style *hibachi*. Entertainer/designer Joan Shepherd chose the room's muted colors, inspired by the tones of the shells.

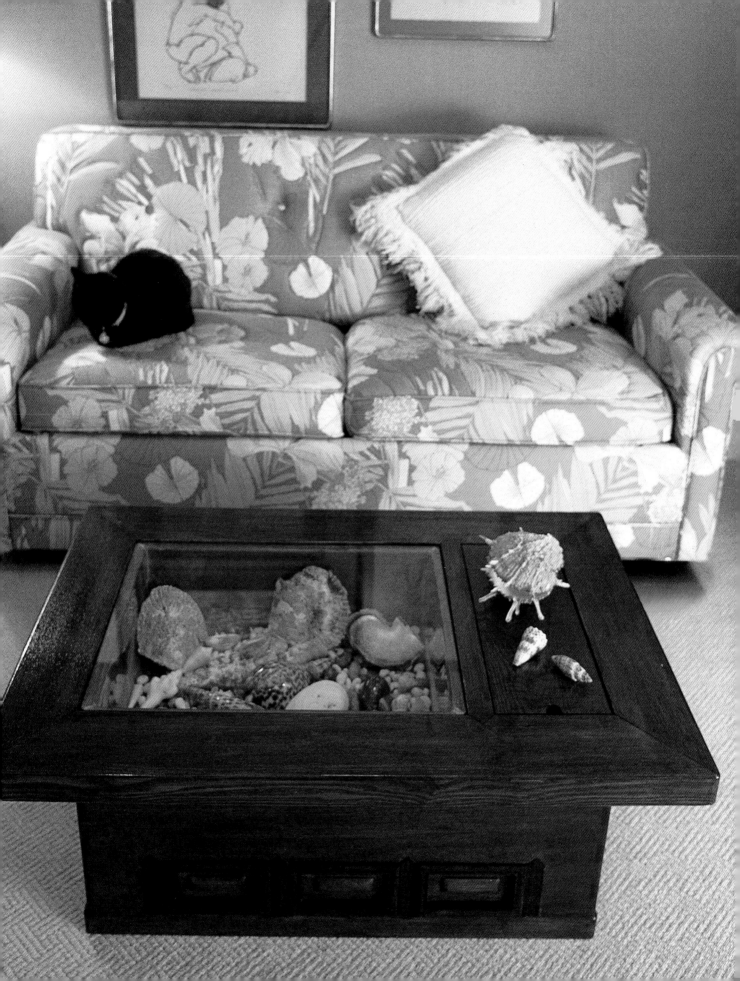

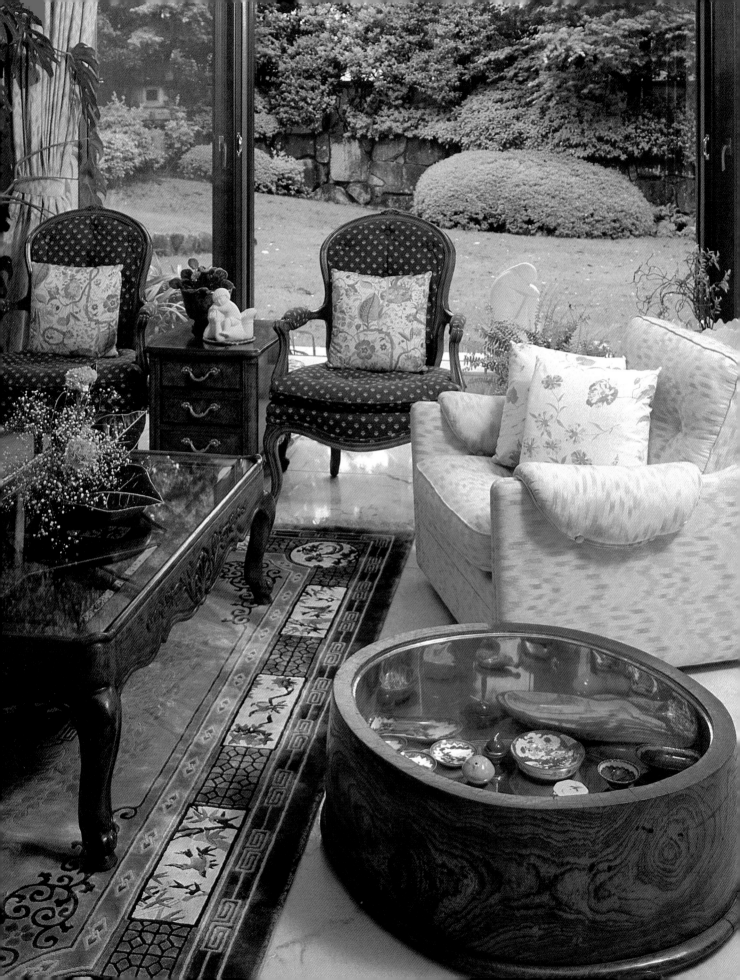

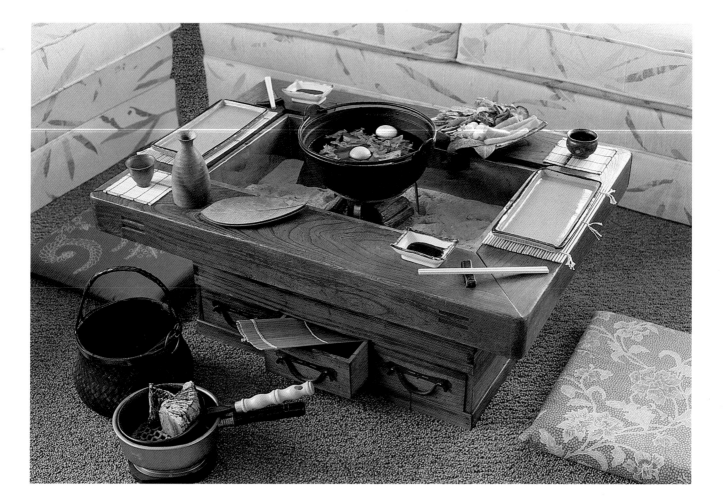

high luster, making it the most expensive of Japanese furniture woods. Paulownia provides excellent insulation and grows so fast that a seedling, planted at the birth of a daughter, would be full-grown by the time she needed bridal furniture.

Wooden *hibachi* come in three main forms: a hollowed out tree trunk, a square box, and a rectangular one. The last is the most common version on the antique scene. The rectangular *hibachi* first appeared during the Edo period (1603–1868) and has evolved to a height of about 14". Those available today at antique shops and shrine sales generally come in two principal forms, commonly referred to as the Kansai (Kyoto) or Kanto (Tokyo) designs.

The Kansai style has a wooden overhang around the ash receptacle that provides a place to rest tea or saké cups. The Kanto *hibachi* usually has straight sides without a lip around the firebox.

ABOVE: Although *hibachi* were not used for cooking, Sara and Ken Hostelley occasionally turn their Kansai *hibachi* coffee table into a cooking center for fondue style entertaining. Special Japanese charcoal, ignited first in the kitchen, gives off little smoke. The tiny placemats are actually *sushi* rollers.

OPPOSITE: *Hibachi* made from hollowed-out tree trunks take many shapes. This simple oval *hibachi*, holding porcelain treasures, is combined with European antiques on a marble floor in the home of Tae Young and Choong Suh Park.

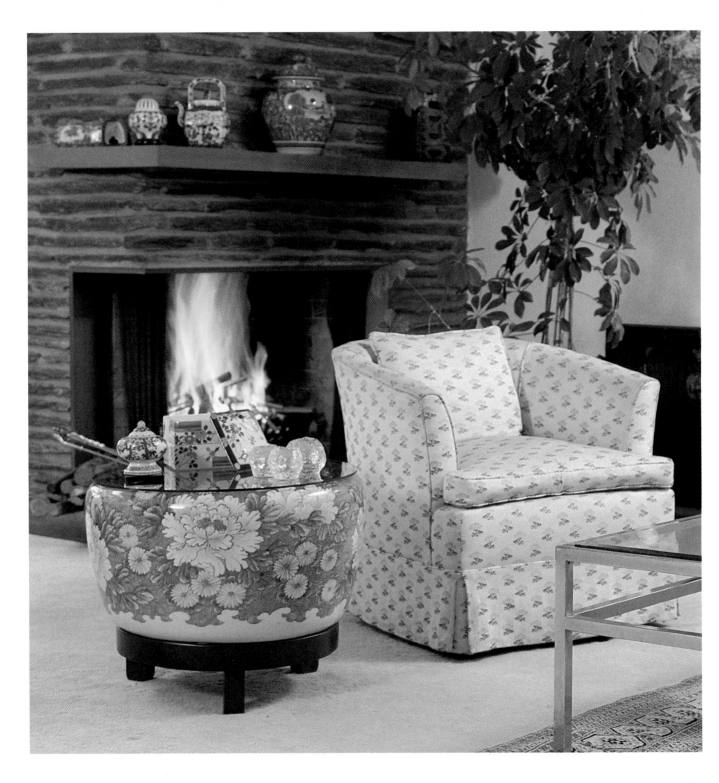

ABOVE: A cherished family *hibachi* nestles appropriately near a modern fireplace and is even more cherished in its second home. Its background: Barbara Boyle and Bill McGovern met across Ari's piano bar. When Barbara and Bill got married, they referred ever

after to Ari of Ari's Lamp Light as their "go-between." On Bill's 40th birthday, Ari (actually Takashi Arifuku), presented Bill with a nostalgic gift, this 90-year-old Imari *hibachi* that had been in his family for three generations.

OPPOSITE: When tea was offered to a guest in "the old days," a hand-warming *hibachi* was given as well. Here, a polychrome Imari *hibachi* plays another gracious role: a champagne bucket for an intimate anniversary toast.

16

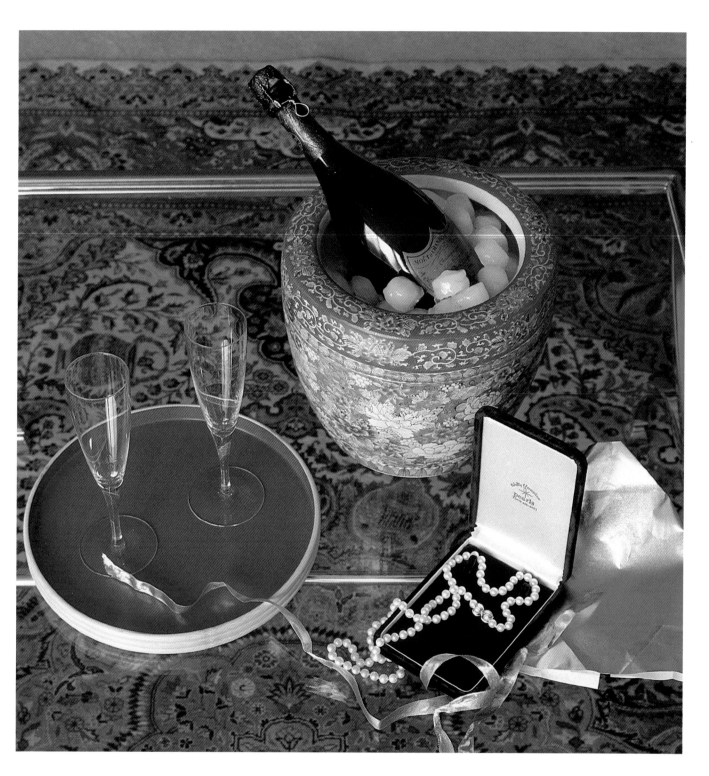

CERAMIC HIBACHI

Ceramic *hibachi* made their appearance during the Meiji period (1868–1912) as porcelainware flourished and porcelain *hibachi*, or more precisely Seto *hibachi*, became the status symbol of the day.

Seto is near Nagoya, but production was not limited to that region alone. Famous Kyushu craftsmen hand-painted many of the blue and white designs, but as demand increased, stencil patterns were also utilized for part or all of the design.

This type of *hibachi* is not seen as frequently as the blue-and-white kind, but is generally less expensive. Its blue-black glaze is called *namako*, and Joan Shepherd fitted it with an oversize glass top to make it a useful end table.

Ceramic *hibachi* were produced in other colors as well. Of these, the polychrome, Imari *hibachi* is the most valuable, since it generally is completely hand-painted. The more recent solid colored *hibachi* tends to be the least expensive, but the quality of any *hibachi* depends on the kind of clay used and the temperature at which it was fired.

While wood and ceramic are the most common materials, *hibachi* also come in lacquer, rattan, and metals.

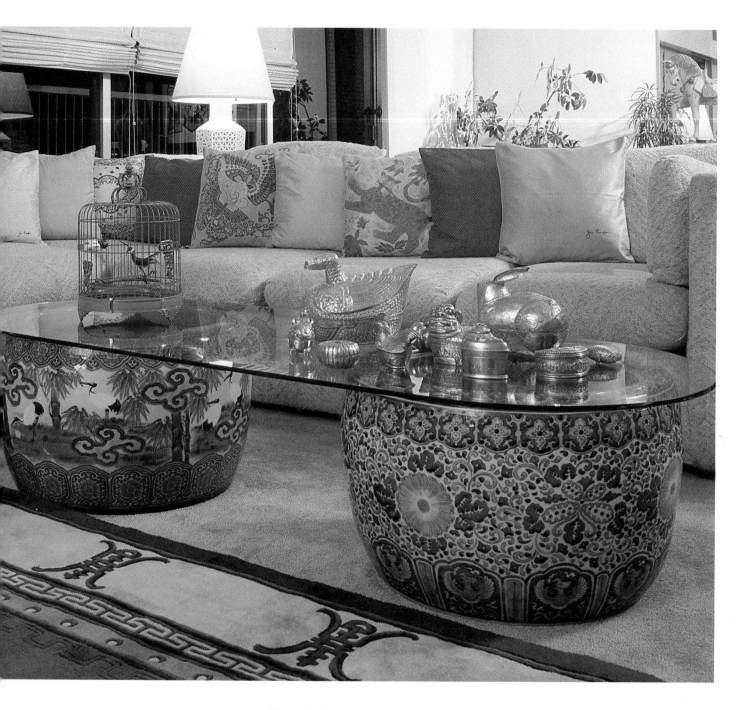

Elliptical glass spans two ceramic
hibachi to make an unusual *coffee*
table in the home of Patricia and
Kevin McNelis. A collection of silver,
mostly Cambodian, is counterbalanced
by a Chinese birdcage.

ABOVE: A hall corner without direct sunlight is brightened continuously through Barbara Ruig's inventiveness. Birch branches, meticulously glued with silk dogwood blossoms, stand in a small portable *hibachi*.

OPPOSITE: The plant is silk; the *hibachi*, authentic! Hand-painted at the turn of the century, the soft blue-and-white porcelain is a natural addition to Barbara and Pieter Ruig's English country living room. Mrs. Ruig masks the base of all her plants, living and artificial, with sphagnum moss.

KOTATSU

In an interesting variant on keeping warm, the people of the Edo period (1603–1868) invented a heater table, the *kotatsu*. It is said that the *kotatsu* developed from the custom of warming bedding on a wooden frame placed over a sunken pit holding a small *hibachi*.

It was soon discovered that if a quilt were left over the *kotatsu* during the day, the spot became a good place to get warm. The family put their legs under the table, and while conversation waxed and waned, the toes stayed cozy. Eventually, portable *kotatsu* in different sizes were designed to be dropped over a *hibachi* anywhere. Later, the infrared lamp complete with thermostat appeared, and so the foot-warming (and heart-warming) *kotatsu* lives on to this day.

Antique *kotatsu* come in many sizes, ranging from approximately 9″ to 36″ square,

and are joined by dowels, not nails. Most stands available today date from 1900 and are generally made of cryptomeria or cypress. More expensive hardwoods were not used, since the stands were covered and subject to burns.

In addition to their ready conversion to tables in Western homes, *kotatsu* can perform a multitude of other jobs as well, serving as telephone tables, plant stands or low foot rests.

RIGHT: Designer Elaine Barchan of Arcadia, California took out the center of a *kotatsu* grid and replaced it with a mirror to form a striking unit with her American pine chest. The obi cord around the lampshade is her innovative way to accent the room's colors. The *mingei* wooden horses come from northern Japan.

BELOW: The removable center of the *kotatsu* described above is used as a trivet in this still life of Elaine and Stan Barchan's hospitality, Oriental style. The Japanese teapot and warmer are contemporary; tea cups, modern Imari; cake plate and flower bowl, antique Imari.

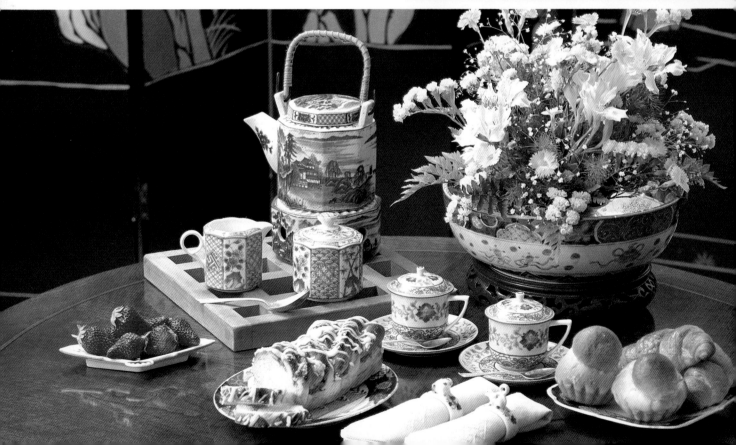

Kimono

The vivid colors of a wedding kimono with its typical asymmetric design are appealing in a family room. This one, top lit by a skylight, displays several auspicious symbols in a fan motif. Fans were often presented as gifts on joyous occasions or were exchanged by an engaged couple as a symbol of their unfolding future. The kimono is hung on a hanger made especially for display purposes.

Among all the intriguing items found in the Japanese culture, the kimono reigns supreme as most representative of Japanese aesthetics and lifestyle. Certainly, it is the most opulent. Westerners have learned to prize kimono as dearly as the Japanese, who pass down ceremonial garments from generation to generation.

Since all kimono are the same size and constructed in the same way from a narrow strip of cloth cut into seven pieces, all of the opportunity for originality lies in the hands of the weavers and dyers. They plan the completed design motif before dyeing the cloth. Since they know exactly where the seams fall, they can create sweeping designs across the panels.

Kimono designs do not suffer from the limitations that sarees and sarongs impose. Since the latter garments are uncut lengths of cloth, they are draped with tucks and pleats, so parts of the material never show. Their patterns, therefore, tend to be small and repetitive.

Kimono designers often conceive the garment as an artist would a canvas for a painting. Their magnificent creations derive largely from nature and its seasons, but they are also inspired by poetry, music, and literature. It is no wonder that kimono serve as splendid paintings on the walls of Western homes.

The design of the kimono has remained largely unchanged through the centuries. It evolved from the trousers and jackets with stand-up collars seen on the ancient earthenware figures (*haniwa*) and moved on to become a South Asian type loose robe with a front slit. With the introduction of wet rice cultivation to Japan in 300 B.C. and the consequent change

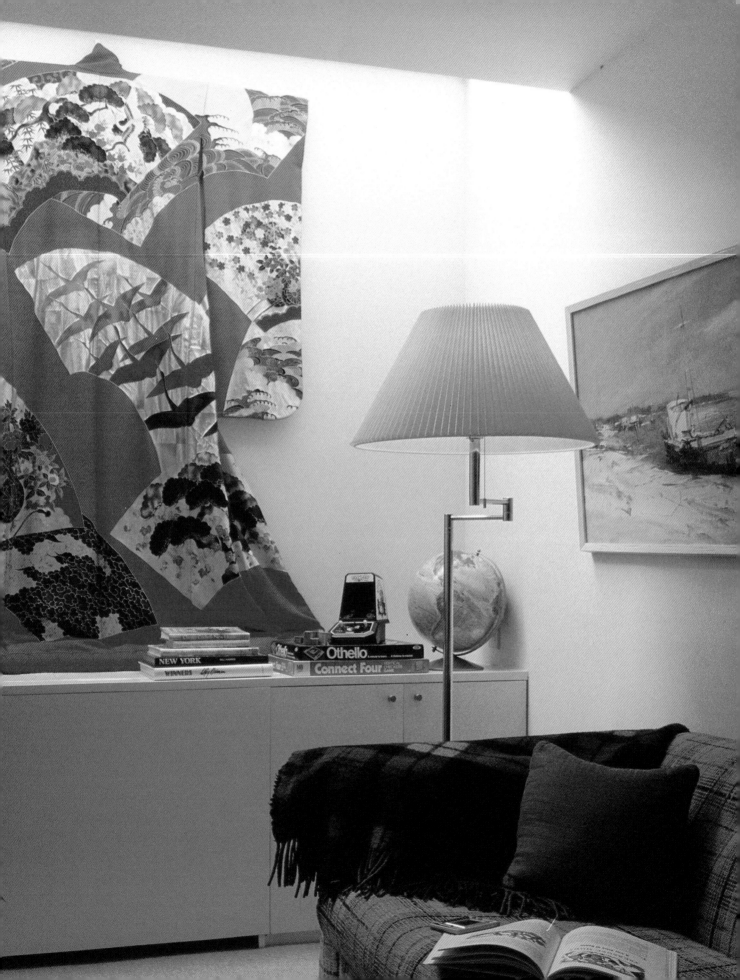

What will the mother of the bride wear? For Japan's traditional weddings, there is but one answer. Married women wear black silk kimono with subdued designs in gold, silver or white below the obi. This ceremonial kimono of possible Meiji vintage adds quiet grace to Rochelle and Bruce Narasin's dining room.

Other kimono are reborn in a new art form. Artist/designer Maureen Duxbury tracks down unusual antique kimono and obi and then refashions them onto folding screens. Her works enhance many a Tokyo interior. This one preserves a married woman's formal kimono, invoking good fortune with the pine, plum, bamboo and crane motif. The two white circles at the top of the screen are the family *mon* or crest, which appears in five places on the formal kimono.

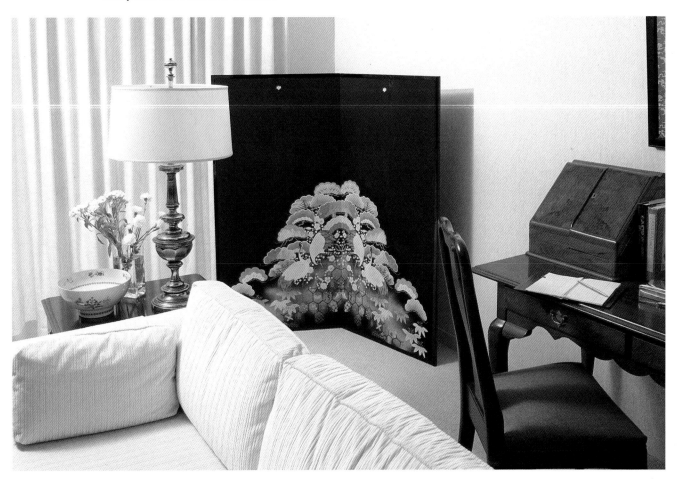

from a hunting society to an agrarian one, farming in the humid climate dictated other changes. The robe was cut open all the way down the front; sleeves were widened, and openings were added under the arms for ventilation.

Japanese clothing reached its zenith during the Heian era (794–1185), when court ladies wore as many as 12 different layers with no two layers of the same color or pattern. By the middle of the 16th century, dress was simplified to one or two layers, and the kimono took its current form.

In the post war years, the pace of life has taken the kimono from the every day scene, but it is still worn with great élan for formal occasions. Kimono are selected according to the event, season, and the wearer's social position, marital

status and age. The patterns and colors become more subdued with each decade in life from childhood on.

Great care is exerted in Japan to ensure that the time-consuming technique of donning a kimono correctly does not become a lost art.

The bridal kimono (*uchikake*) is so elaborate that the bride requires assistance to put it on. Often a hair stylist and makeup artist are also in attendance. The most exquisite examples of those ceremonial kimono are made of silk brocade. Though they are extravagantly priced

when new, second-hand kimono at antique shops, shrine and department store sales are very affordable decorating accents. Many are in perfect condition. Older kimono are one-of-a-kind works of art created by techniques that are now too expensive to duplicate.

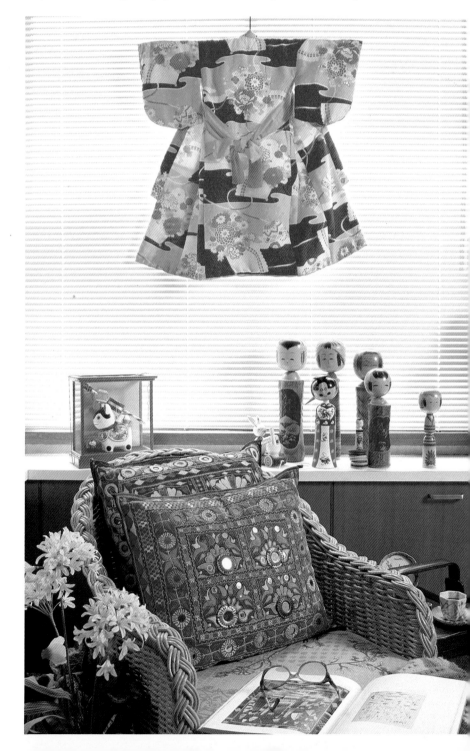

RIGHT: Elaine Barchan screened out a frenetic view of Tokyo with a child's kimono. A little girl wears this sort of kimono to celebrate *Shichigosan* on November 15. The 400-year-old Shinto festival, meaning "seven-five-three", celebrates children's arrival at these important stages. Girls, ages three and seven, and boys, age five, are still taken to the local shrine to give thanks and invoke future blessings.

OPPOSITE TOP LEFT: Even babies observe their first important ceremony in kimono. A newborn is welcomed to the community by being presented at the neighborhood Shinto shrine. A small kimono is draped over him as he is held by his maternal grandmother. Today, a boy is usually brought for the *miyamairi* ceremony on the 32nd day after birth, a girl on the 33rd. Rochelle Narasin recognized this antique kimono as worthy of her collection.

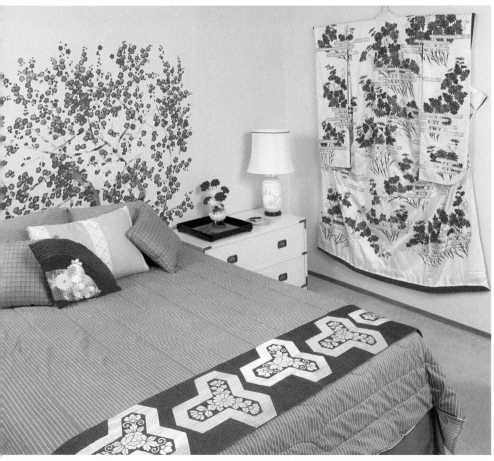

ABOVE RIGHT: Some kimono are actually quilts. *Yogi* or *kake-buton* have an extra panel of material in the back and are heavily padded. They are spread over the sleeper with the design facing up. Helen and John Spencer prize the homespun artistry of this century old indigo-dyed cotton version. The family crest is a type of mandarin orange.

LEFT: Susan Paul Geffen chose the plum blossom wallpaper mural for her guest room during her first week in Japan. A year later, the silk wedding kimono, resplendent with chrysanthemums, surfaced at a shrine sale. According to legend, the chrysanthemum assured longevity to anyone who drank a brew made from it. A crimson obi makes the perfect link across the bed.

29

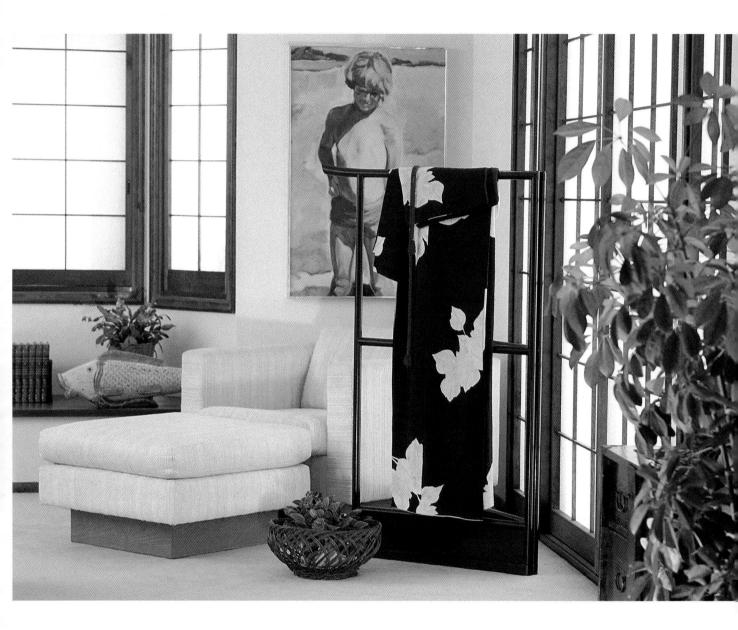

Rochelle Narasin decided to decorate
her new home in Tokyo by
concentrating on Japan's splendid
textiles. This modern kimono, draped
informally over a hinged kimono stand,
turns a corner of the living room into
a regal retreat. The dash of red is an
obi cord. The portrait is an
oil by Mrs. Narasin.

Lacquer

Ogden Nash declared, "God in wisdom made the fly and then forgot to tell us why." The Japanese, however, know why He made poison sumac. For lacquerware!

The refined sap of the *urushi* tree of the sumac family provides the highly decorative, protective finish that ranks among the most distinctive achievements of traditional Japanese crafts. Because it can cause severe rashes, great care must be used in applying it.

From one to 20 or more layers of a film-thin coating of the sap are applied to a piece. Each coat takes two to three weeks to dry. The end product is a lustrous, highly stable finish that is impervious to most substances, including high heat and moisture. Durability of lacquerware, however, depends on a base of carefully seasoned wood. Otherwise, fluctuations in heat and humidity cause the lacquer to crack and peel.

Lacquer has been found in

Two lacquered stacked food boxes, used to take food on outings and to present food on ceremonial occasions, are ready for Susan and Steve Geffen's buffet, as is the soft sculpture by John Harris, called "Lunch Counter." Wooden Japanese trays serve to display a Chinese picnic basket and the black lacquer *bento* box, decorated in gold and silver leaf. The large bread basket is from the Philippines.

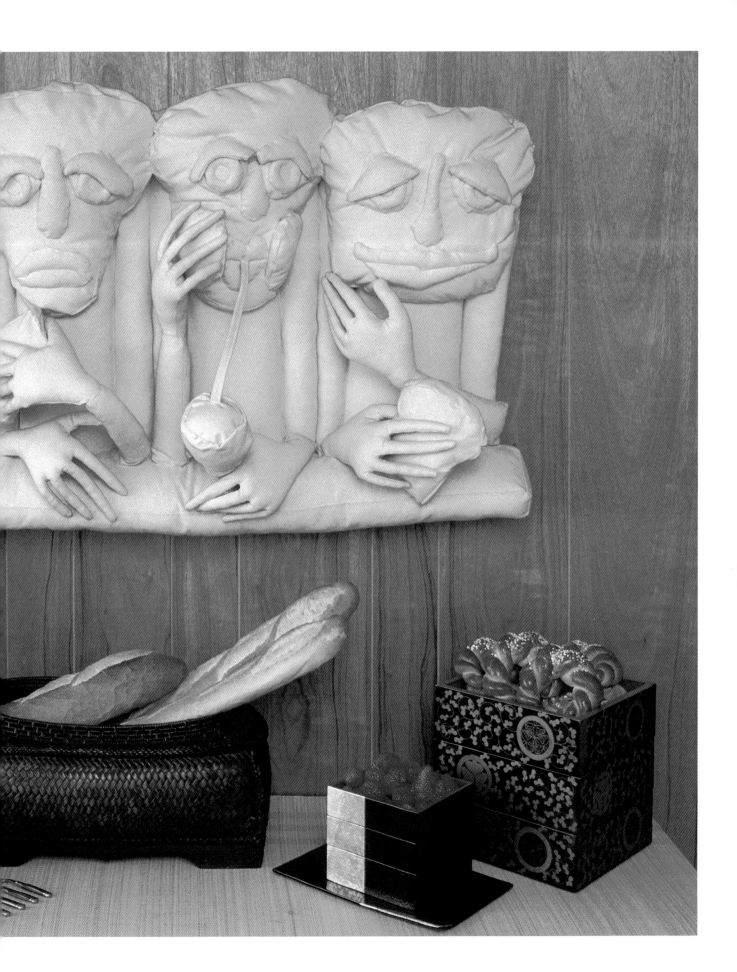

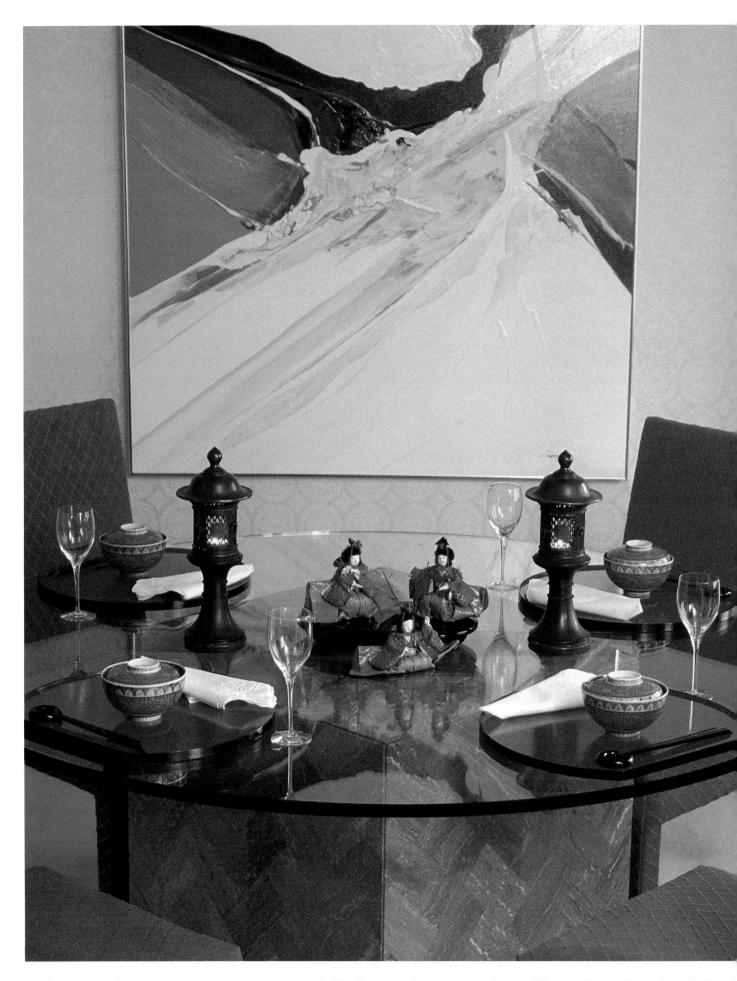

BELOW: Although the Japanese have long used square trays for individual place settings, these lacquered "placemats" are actually the lids of stylized food boxes. Margot Burton combines them with *yukata* squares, contemporary hand-painted dinner plates, antique cups and an obi, handwoven from silk and cotton remnants in a ragweave technique called *sakiori* for a festive table.

OPPOSITE: Lacquer trays become placemats when Sally and Russ Porter entertain. Late Edo, Imari soup bowls underlined by lacquered chopsticks announce Japanese cuisine. Swedish crystal, bronze temple lamps and *Hina* dolls swathed in brocade complete this elegant picture. The table's base is Italian marble; the oil, by Gregory Deane.

Japan on fragments of pots and baskets thousands of years old. The art was reintroduced to the country from China in the third or fourth century and became highly developed in the Heian period (794–1185), especially with the introduction of mother-of-pearl inlays and *maki-e*, which means "sprinkled picture." Lacquerware for the aristocracy began to be decorated with sprinklings of gold and silver powders in this period. By the Muromachi period (1333–1573), lacquerware was being exported back to China. At this time too,

High tech meets ancient artistry as a portable CD player and cassettes are attractively unified on lacquered serving trays. A smoking box holds the cassettes under the beaded Burmese tapestry. The tall candlesticks belonged to Susan Geffen's great grandmother and were the sole possessions she took with her to the U.S. from Russia.

lacquered objects became available for common use.

When the capital moved from Kyoto to Edo (Tokyo) to mark the start of the Edo period (1603–1868), the very ornate *Edo-makie* using gold and other colors was developed, and lacquerware experienced another renaissance.

Lacquerware has again become a luxury, and this awareness should be a shopping guideline. Many plastic imitations are on the market, which do not compare in weight, feel, appearance or price to the real thing.

Serving dishes, trays, stacked

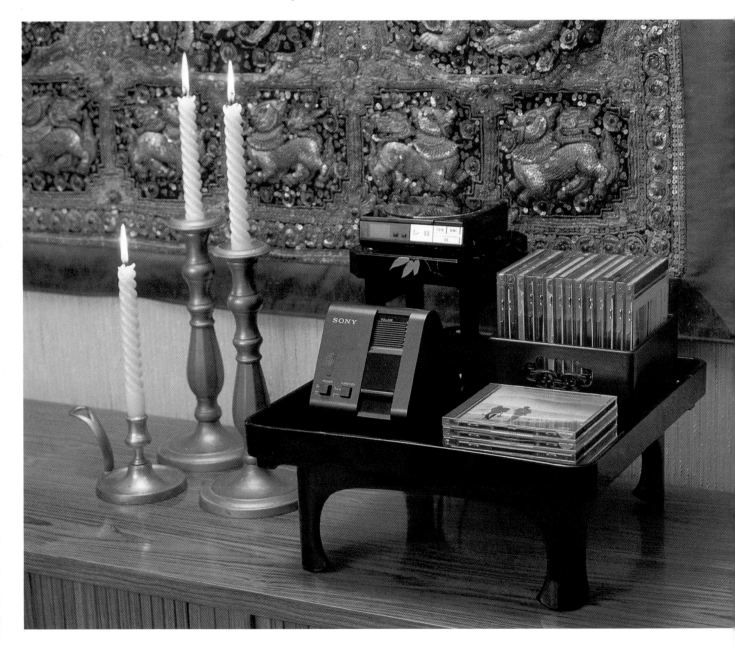

food boxes all make frequent appearances in Western homes. Kimono boxes, however, are rarer guests. In former times, the Japanese switched seasonal wardrobes on two given dates, June 1 and October 1, no matter what the weather. Off season clothes and kimono were stored in the closet in handsome lacquered boxes or baskets. Antique storage boxes in various sizes can still be found in shops, or they can be bought new in the Ningyo-cho section of Tokyo, where family shops preserve a craft handed down for generations.

Lacquered individual tray tables are stacked to become a sleek end table. This particular style on tall legs was used in the more affluent homes. Everyone ate from individual trays while seated on the *tatami* until the Meiji era (1868–1912), when low communal tables came into use.

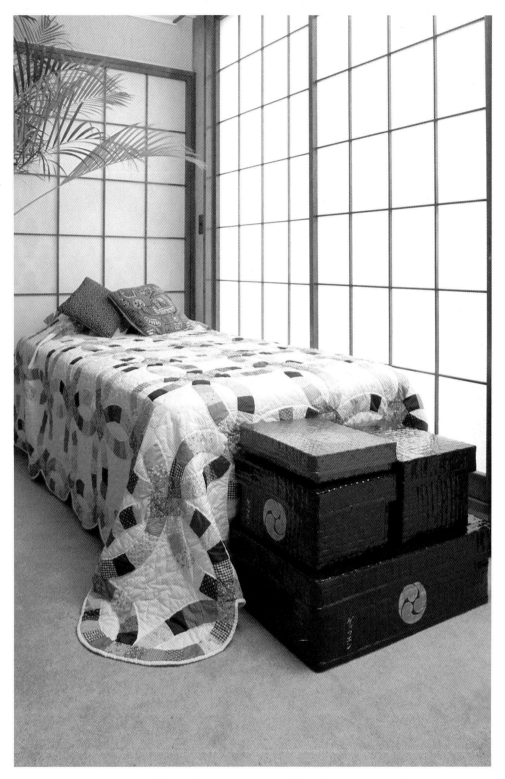

Kimono boxes come out of the closet
just as fine Japanese storage chests
did when Westerners arrived at the
end of the nineteenth century. Susan
Paul Geffen bought these in the Ningyo-
cho section of Tokyo, where she had
them personalized with her name. The
bamboo boxes covered with lacquered
paper (*tsuzura*) combine effortlessly
with an American wedding ring quilt
from the Adirondack Mountains.

The obi, the wide sash worn with kimono, can be as stunning in home decoration as it is in Japanese fashion.

Created to reflect the seasons as well as the occasion, obi come in an astonishing array of colors and designs, from casual to ceremonial. Although fabric varies as well, the most interesting ones are of woven silk, representing Japanese textile design at its finest. The obi evolved gradually from the eighth century. It took its present elaborate form in the

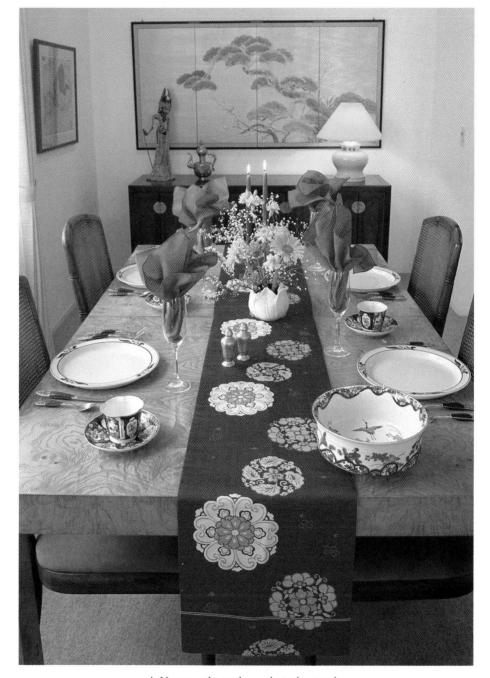

A Nagoya obi, with a relatively simple design, was plucked from a second-hand pile at the Heiwajima Fair to be reborn as a table runner. Its color highlights a touch of cinnamon in the dinner plates.

1700's when Japanese textile art reached a new high.

Since kimono don't come in varying lengths, the extra material is folded over at the waist and concealed by the wide sash. The obi is often considered a more important part of a woman's attire than the kimono itself, and accessories are chosen to enhance the obi. A good obi sometimes costs many times the price of a kimono. It is selected to contrast with the kimono. Kimono with woven patterns are generally

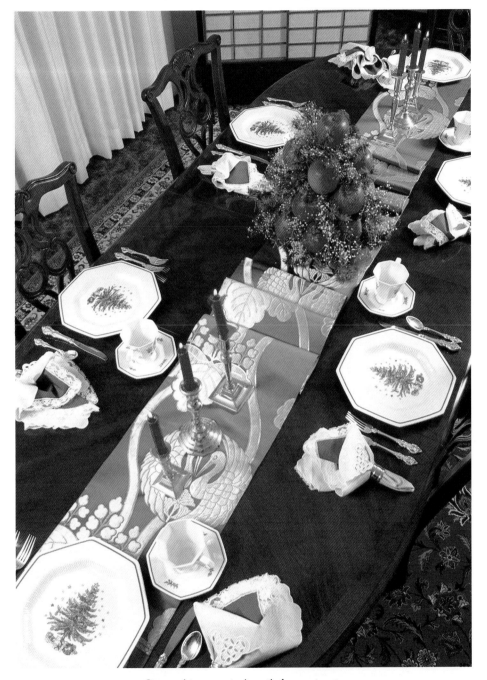

Since obi range in length from nine to twelve feet, they are ideal for extra-long tables for entertaining. Red and/ or green obi, make holiday parties festive as Martha and Michael Schreier's elegant table shows.

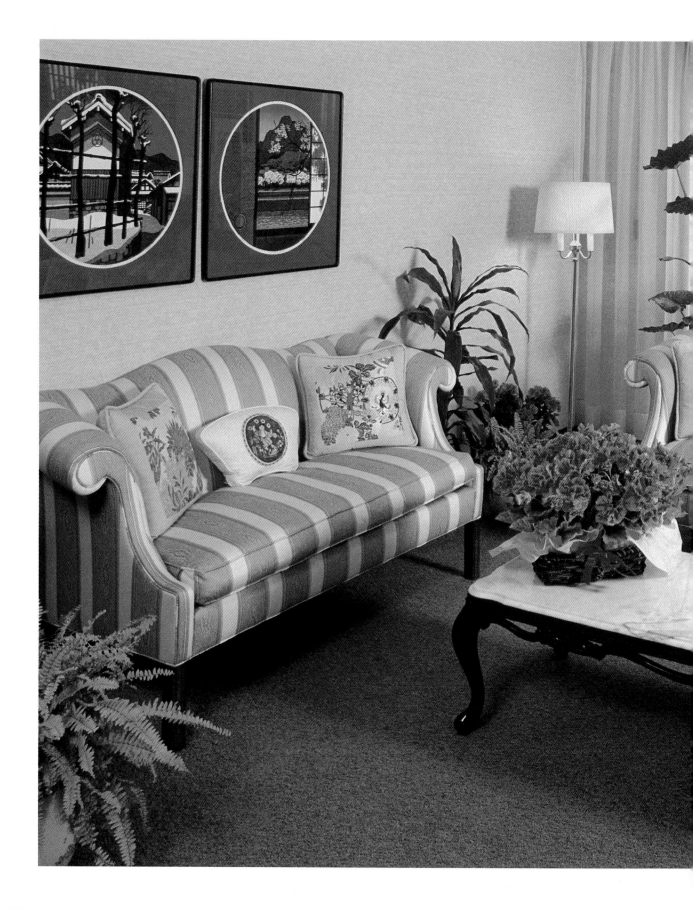

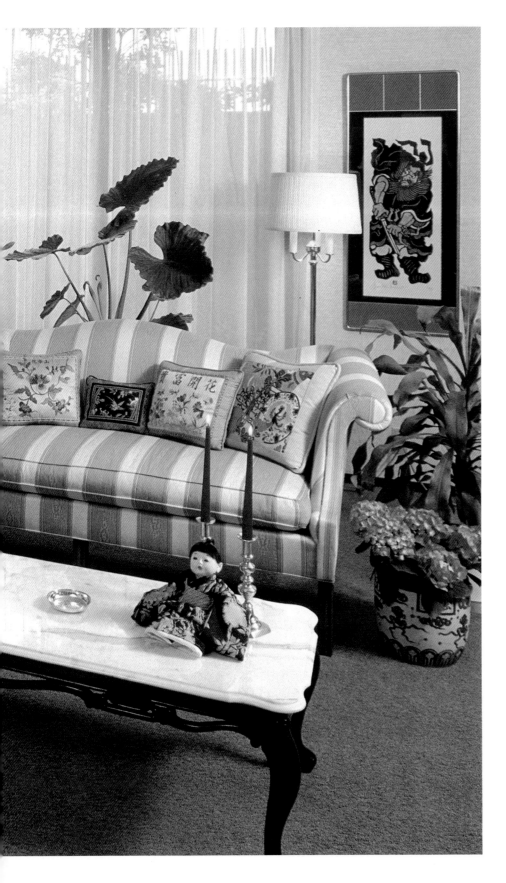

worn with dyed obi and vice versa. One kimono may be worn with several different obi to change the effect.

Some Tokyoites make the rounds of shrine fairs and antique markets looking for obi to make into wall hangings or bed quilts. Second-hand brocade (*nishiki*) obi can be found at a fraction of their original cost. The obi's one-foot width offers endless opportunities for unique accent pillows as well.

When shopping, unfold the obi to see how much of it is patterned. Some are patterned on both sides; others have the design on 60% of their length. The Nagoya obi has a narrow portion pre-folded that is easy to unstitch.

The obi can be tied in literally hundreds of different ways—estimates go from 300 to 500—with new bows still appearing. The shape of the bow is determined by the occasion, the age and even the marital status of the wearer. One how-to book lists 18 steps to make a standard bow. The inventive decorating uses shown here are much easier.

Pieces of obi and Chinese embroidery were fashioned into silk pillows by Designer Elaine Barchan to enrich Kathleen and Bob Nagro's living room. Other Japanese accents in the scene include woodblock prints by Clifton Karhu and a handmade doll.

RIGHT: While some people frame portions of elegant obi for richly textured additions to their art collections, Patricia McNelis decided to use a portion of an obi as a mat for two prize antique prints. The flower arrangement in the piece of freshly cut bamboo is an original creation by Mrs. McNelis, who is an associate master in the Ichiyo school of *ikebana*.

BELOW: Many elaborate weaving techniques belong only to the past. This obi, preserved in a frame in the home of Margot and James Burton, was precious even when it was first presented as a *sayonara* gift in 1941. It was given to the director of the Ford Motor Co. when the firm closed its operations in Japan at the outset of the war.

The director gave it to his sister, who later fell into difficult financial circumstances. She tearfully sold half of it for five dollars to Mrs. Burton's mother, Helen Wilson, who remembers well that five dollars then could buy a lot of food. That half obi has now returned to Japan along with another bit of its history: the obi is thought to have been a gift from the Emperor.

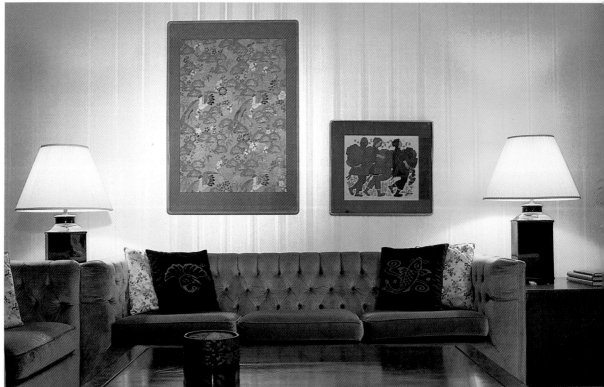

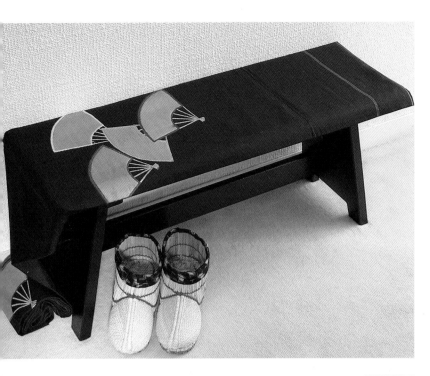

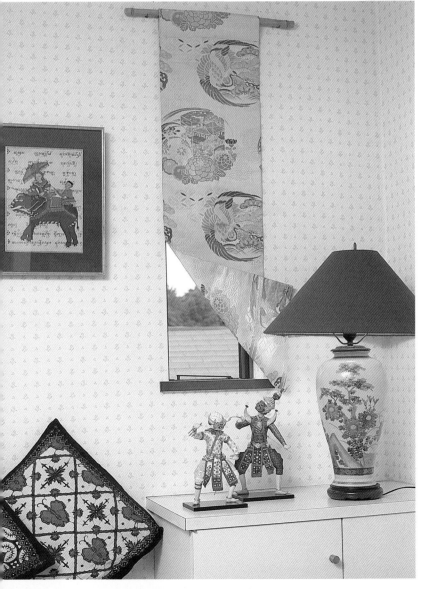

ABOVE LEFT: While obi often provide versatile material for upholstered cushions and bench seats, sometimes it isn't even necessary to cut them for the desired effect. Cindy and Jim Gastonguay wanted to provide seating in their entry way for the removal of shoes. Mrs. Gastonguay found an unpainted bench at a do-it-yourself store, sprayed it black, and simply draped this just-right obi over it. The excess is cleverly folded to capitalize on the fan motif. Old-fashioned snow shoes complete the picture.

LEFT: Angelia Huse let an obi solve a problem in her family room. Two very small windows directed sunlight on the TV screen. An obi became a combination curtain/wall hanging, and a difficult window became an interesting one.

And then there are obi turned sculpture. Sara Hostelley calls this group of rolled woven obi her "*ikebana.*" Although she discontinued her study of flower arranging, this display lives on, presided over by a puppet made of padded silk. Mrs. Hostelley mounted the puppet on a ground of ledger paper and framed it without glass.

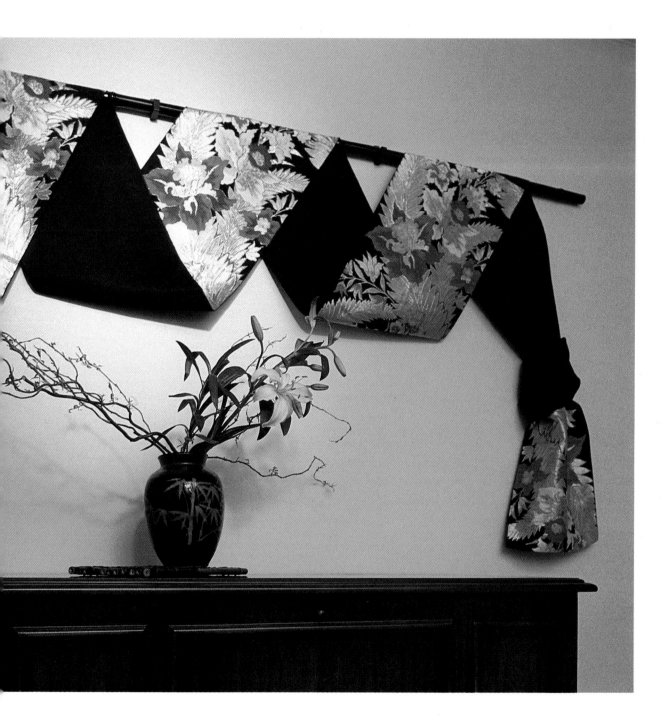

A wedding obi, gleaming with gold thread, emerged from a Togo Shrine sale. Ronna and Keith Pandres added a piece of bamboo enhanced with high gloss paint and tied a creative knot. Positioned over an American hope chest, the obi transforms their dining room into another timeless East-West marriage.

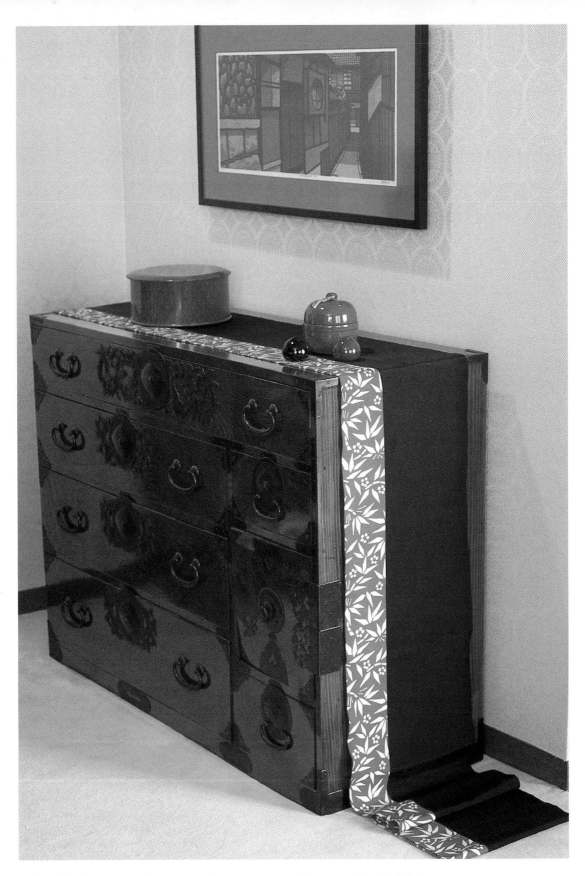

The right obi, strategically positioned, can add color or soften the lines of furniture. Sally Porter hesitated before buying this one for her cinnabar accented living room. Then she turned it over and discovered its black facing provided the perfect backdrop for the lacquered caviar servers and the 19th century rice bowl on the Sendai clothing chest.

Ceramics

Westerners need little assistance when it comes to living with one of the crowning glories of Japanese culture, its fine porcelain and pottery. The country's islands contain all the major types of clay, and its rich history of working with them stretches back 12,000 years. Its modern history began in the 17th century when Korean potters in Kyushu discovered the existence of the kaolin clay needed to make the high glaze porcelains of China and Korea.

Even during Japan's centuries of isolation when all foreigners except Chinese and Dutch traders were expelled, Japanese porcelains were made for export and matched sets, designed expressly for Western tables, found their way to Europe.

The various kinds of porcelain originating in Japan are renowned around the world, and information about their development is readily available. Black Ship porcelain commemorates the resourceful Dutch traders. Sometsuke is

Hand-warmer *hibachi* and Chinese *sumi-e* brush cups become collectibles in Suzette and Peter James' gourmet kitchen. They hold a formidable battery of kitchen tools.

recognized by its cobalt blue and white designs. Arita is more commonly known as Imari after the Kyushu port from which it was shipped. One also finds Kakiemon porcelain with its brilliant red overglaze enamel, Kutani ware known for its rich green, and delicately painted Nabeshima . . . each name speaks volumes. Patricia Salmon's *Japanese Antiques* is a good starting point for an overview for the would-be collector.

Japanese Accents, however, is concerned with identifying unusually shaped objects found in Japan to show how they can serve completely different functions in Western homes. The field of ceramics presents some shapes that need introduction.

OPPOSITE: A delicate porcelain saké cup stand holds sugar crystals and looks as if it were made for this elegant table. Barbara Ruig mixes modern Lenox china with individual pieces of old Imari collected over the years from various antique sources. The Belgian linens coordinate with the off-white china.

LEFT: Westerners are inevitably charmed by the miniature porcelain figures designed to hold the food-bearing ends of a pair of chopsticks. Someone has actually found an ingenious use for chopstick rests on the Western table: place cards. The best choices are rests with enough white space to write a name with a washable felt tip pen. One could select a set or start a theme collection. The possibilities are endless, since the rests are inexpensive and readily available.

TOP LEFT: Ceramic pillows have been turned into lamps, door stops, even a soap dish. The elaborate greased coiffures of yesteryear could last several days if slept on carefully. Men and women rested their heads—or more precisely their necks—on rigid pillows. The ceramic version kept the head cool during summer. Some models had small holes for perfume to scent the coiffure.

TOP RIGHT: Some specialized pieces of Japanese porcelain perform innovative functions in Elaine Barchan's powder room. The fan-shaped boxes holding soap are serving dishes. A saké cup stand and a chopstick holder contain makeup brushes.

BOTTOM: The graceful, footed Imari dish about to join the party, bearing a colorful salad, began life 150 years ago as an *ikebana* container. It is a traditional shape, designed for display in the *tokonoma*, the focal point of a *tatami* room. Suzette James uses it for her own flower arrangements too, but finds that it is a decorative piece even without anything in it.

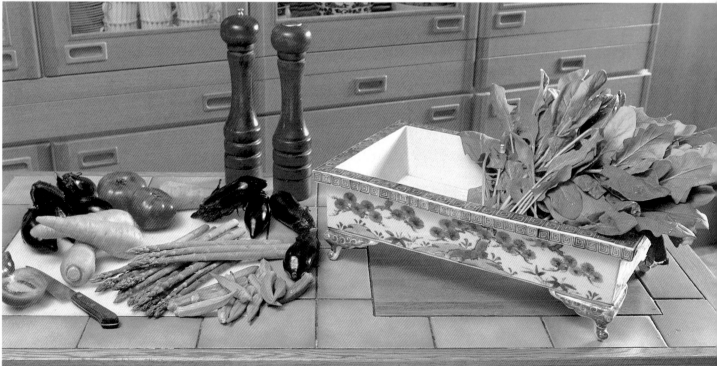

Lighting

Often overlooked, the Japanese lantern or *andon* is an extremely effective decorating device. Indoor, outdoor, hanging, hand held, free-standing . . . there are many designs from which to choose.

Ancient lamps burned a small dish of vegetable oil inside the light chamber. Oil gave way to candles, which in turn were replaced by kerosene introduced in the Meiji Era (1868–1912).

Bronze temple lanterns, *seido-toro*, used for Buddhist worship, first came to Japan in the Nara period (710–794). In those days, temple ceremonies were held at night, and the native Shinto religion quickly adopted bronze lanterns, along with several other facets of Buddhism. Some of the standing lanterns were used on the altar itself. Others were used in small classrooms, which were part of the temple complex. Many of the lanterns were donated to the temple as votive lights in petition for a special blessing.

Until the sixteenth century, hanging lanterns were used in temples or shrines for ornamental rather than functional purposes. Often, they were hung outside at the four corners of the building or were grouped together under the eaves. With the refinement of the tea ceremony culture, hanging lanterns came into private use, where they were hung under the eaves of the house or in the garden. Hanging lanterns are recognizable not only by their suspension loops, but also by their little roofs. They can be paper over bamboo basketry, small wooden *shōji* houses, or metal with open grillwork.

The framed paper *andon*, which was the most common of all the floor standing lamps for home use, became popular in the Edo period (1603–1868). It has a wooden frame covered with paper to shield the oil wick or candle from the wind. The light chamber may be either rectangular or cylindrical and is open above and below. These lamps are usually finished in black, red or brown lacquer and some have tiny drawers in the base for wicks. Occasionally a cube-shaped *andon* will sit on a wooden base that has small crescents cut in each face, as is shown on page 75. The base is a second shade which is slipped over the *andon* to reduce the light.

Imaginative lighting, however, is not limited to antique fixtures as three of these photographs demonstrate.

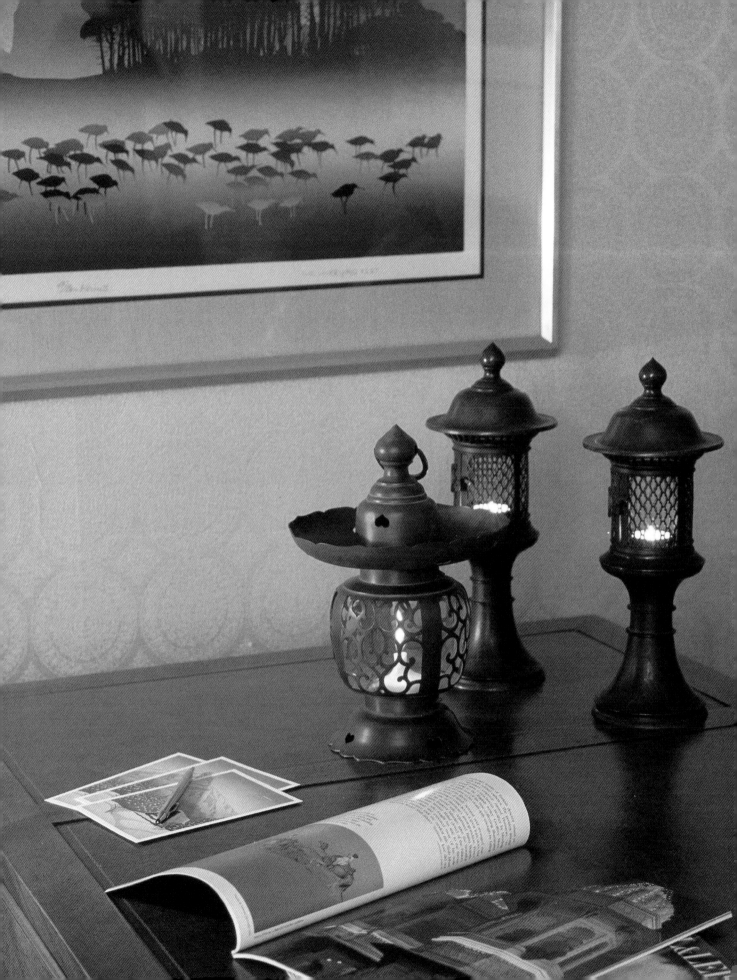

Having once welcomed guests to a restaurant, a lacquered *andon* with an electric light now graces Susan and Steve Geffen's apartment foyer. The unusually shaped clogs, *geta*, are for the garden.

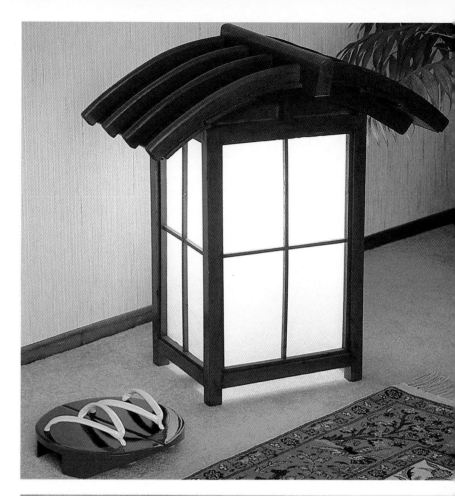

This hanging cedar temple lamp, about 50 years old, is one of Barbara Ruig's versatile accents. Here, its flickering candle provides gentle light in a powder room, but occasionally Mrs. Ruig places it in the foyer to welcome guests with its warmth.

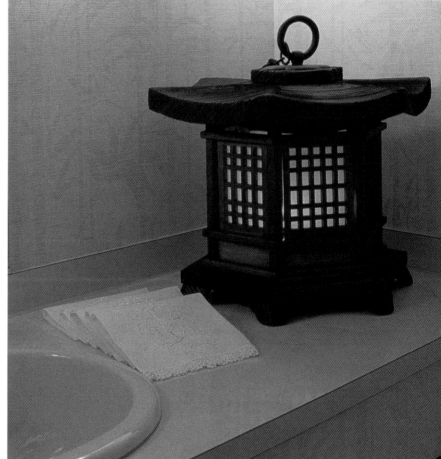

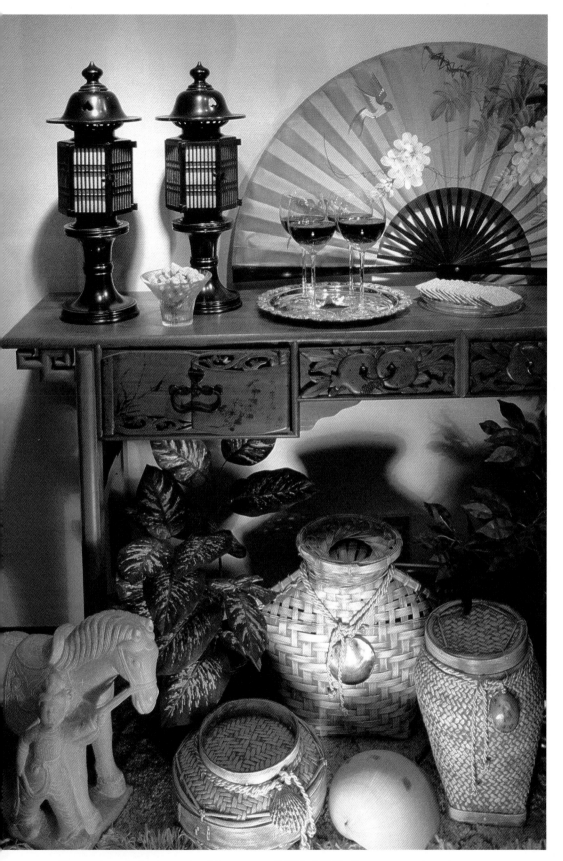

Bronze temple lanterns stand in solemn splendor in Doris and Peter Cohen's dining room. The pair, with unusual rectangular light chambers, were most likely a private donor's gift to a temple in the Meiji era (1868–1912). One was purchased recently near Kyoto and the other, an exact match, was found against all odds in northern Japan. The serving table is made from a portion of a Chinese bed.

Sally and Russ Porter found that the soft glow of two Japanese lanterns totally changed the atmosphere of their living room. This handsome antique lacquered *andon* is one that weathered the transition from oil to candle to electricity. Designed for Japan's floor-seated lifestyle, it is equally effective in a Western home, since it casts a larger circle of light than a lamp at table height.

An oversize earthenware "teapot" or *dobin* illuminates a plant corner. To set the mood, Joan Shepherd simply dropped a small spotlight inside the *dobin* to pour indirect light onto the plants. The cord is camouflaged by a few leaves.

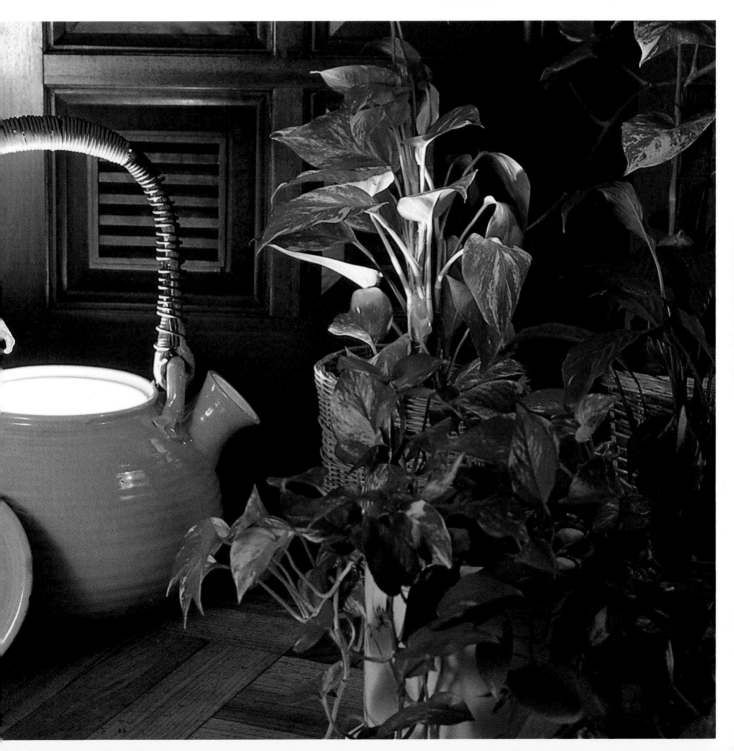

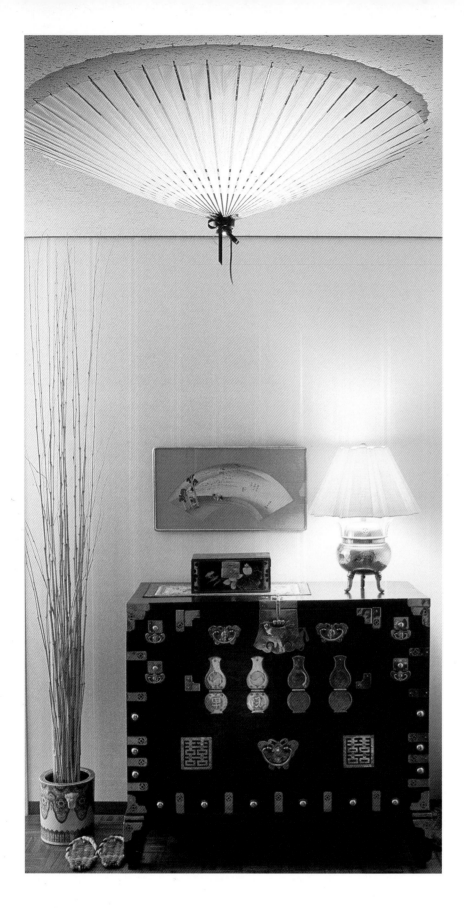

A harsh light fixture in a Tokyo foyer is muted and concealed by a handmade paper umbrella. An unconventional straight-sided *hibachi* holds the dried bamboo next to the Korean chest.

FUROSHIKI

The ingenious *furoshiki*, the square wrapping cloth that was the precursor of both the shopping bag and the knapsack, lives on. It may well make it into the 21st century.

Gifts, possessions or any objects to be carried are positioned in the center of the cloth and the diagonal corners are knotted in the middle to form a handle. Special occasions such as weddings often call for silk wraps. Cotton and synthetics are for *everyday* use. *Furoshiki* come in an endless number of designs and many sizes from approximately one-foot square to a nearly eight-foot square used for packaging Japanese bedding. When its contents have been removed, it is easily pocketed for the trip home.

The word *furoshiki* literally means "bath rug," and it came into common usage in the early part of the Edo period (1603–1868). Although the concept had been used for centuries, the word was coined when the cloth began to be used at public bathhouses for undressing. Street clothes were wrapped in the *furoshiki* during the bath, and afterwards it carried toilet articles home.

Rochelle Narasin was inspired by the *furoshiki* to create her own. Her hand-painted motif of pine, plum and bamboo—the triple symbols of good fortune—is the traditional wreath design that originated in Okinawa, the birthplace of many original and beautiful country textiles. Casually draped over a love seat, it lights up her living room with its artistry.

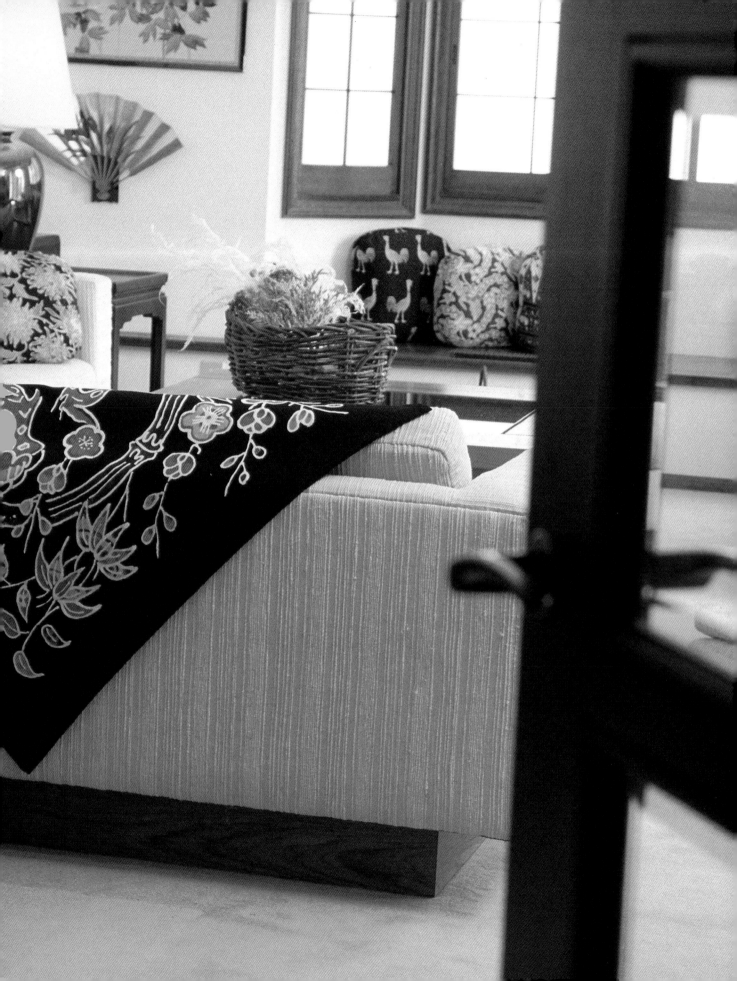

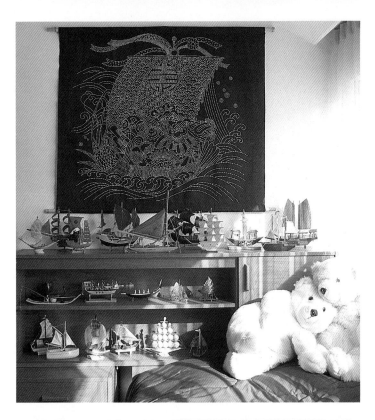

LEFT: A cotton *furoshiki*, from a hotel gift shop, serves two new purposes in a boy's room. In earthquake-prone Tokyo, it is a lightweight decoration over his bed, and also provides a nautical backdrop for his collection of sailing ships.

BELOW: A cotton *furoshiki* is knotted around the bread basket centerpiece on Kathleen Nagro's table. Handpainted contemporary Japanese placemats are combined with a simple *tenugui*, upgraded to a table runner. A *tenugui* is the rectangular cloth that farmers and workers use as a headband.

YUKATA

Yukata, after-bath cotton lounge robes, long ago became respectable even for informal street wear on a hot summer day. Narrow lanes still provide glimpses of people wearing them home from the public baths. And visitors to Japanese hotels delight in finding *yukata* waiting crisply folded in their rooms.

Cotton is a semi-tropical plant; it is not indigenous to Japan, nor readily suited to its climate. Supposedly, it was first brought to Japan by the Japanese General Hideyoshi in the 16th century, a momentous souvenir of his failed invasion of Korea. The Japanese discovered that cloth woven from its fiber was more comfortable than the fabrics they had been wearing made from the fibers of wild and cultivated plants. By the mid-Edo period (1603–1868), cotton was grown all over Japan except in the coldest regions of Tohoku and Hokkaido.

Yukata prints, traditionally

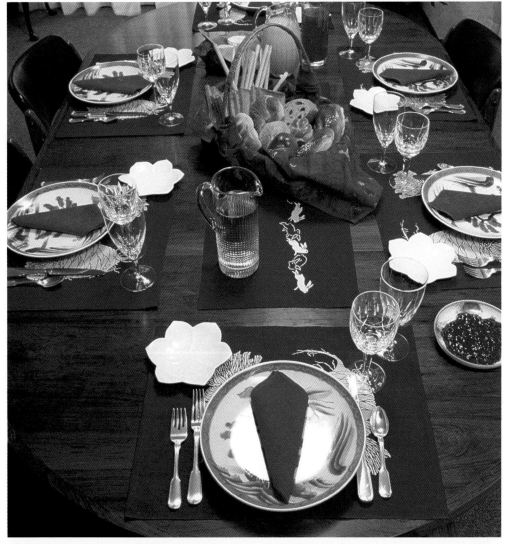

Sunny Yang, remembering the warm
quilted clothing of her native Korea,
was inspired by *yukata* fabric to create
a handmade bed quilt in the early
American tradition. Her theme is
Japanese family crests combined with
new motifs of her own design. The
result with its Imari coloring will be as
priceless an heirloom as a piece of
antique china.

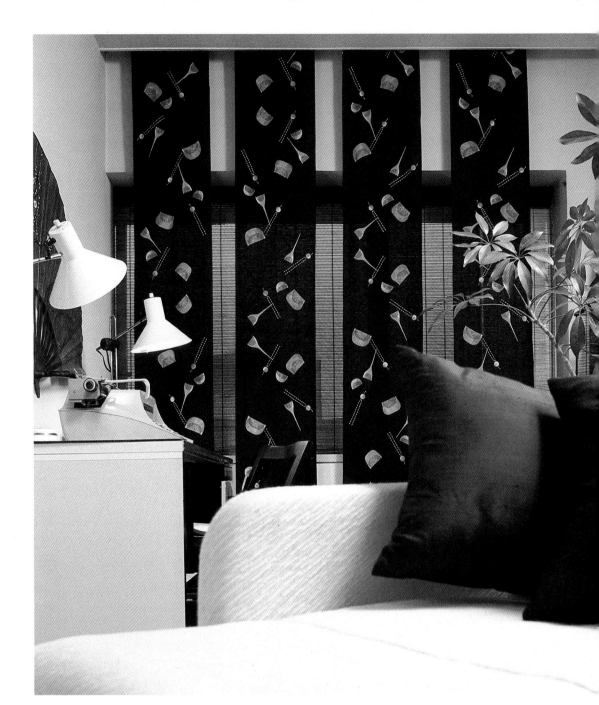

blue and white, come in literally thousands of patterns: geometrics, stylized celebrations of nature, charming renderings of folkcrafts. In the past, all the designs were cut by hand from strong handmade paper. A rice paste resist was applied to the portions to be left white and the entire bolt was then dyed in indigo. Today, much of the material is machine-produced, but the traditional designs are still valued for their artistic quality.

Inventive shoppers put the $14\frac{1}{2}''$ fabric to work in a great variety of tasks: placemats, pot holders, cushion covers, picture frame covers, tea chest coverings. (Bolts generally measure 13 yards in length.) This book presents two uses, one a stunning example of cross-cultural harmony and the other, a marvel of simplicity.

ABOVE: Patricia McNelis used the narrow *yukata* fabric to great advantage as a window treatment in a guest room. Since the fabric has selvage on both sides, stitching was necessary only at the top and bottom. She added small dowels in rod pocket at the bottom for weight and attached pleater tape to the top to receive the hooks from the ceiling tracks. In another residence, the almost-new fabric could be put to other uses.

KASURI

Another colorful country textile, *kasuri*, entails dyeing a pattern into the yarns before they are handwoven. Bundles of yarn are tightly bound at certain points to resist coloring when the skein is dipped into dye. These yarns will then serve as the warp or weft on the loom, producing patterns with a streaked watery effect. This technique, known as *ikat* in the textile world, is called *kasuri* in Japan, derived from the word "to blur."

Kasuri techniques came from Indonesia or China to Okinawa and moved north to Japan in the eighteenth century. Some researchers trace the roots of Japan's *kasuri* technique to a 12-year-old girl, named Inoue Den, who lived 200 years ago in Kurume, and who seems to have created the technique on her own. Through the generations, *kasuri* has become highly refined. Today, no less than 35 steps are involved in some *kasuri* productions with many of them directed toward mastering the indigo dye. Indigo becomes a dye through the action of living bacteria, which must be tended daily until properly fermented.

Although these country textiles were originally woven in the home, they gained wide popularity and became high fashion, as is seen from their appearance in woodblock prints of the Edo period. *Kasuri* fabrics were also used in household furnishings, especially quilt covers. Today their pleasing designs and sturdy construction make them extremely useful for upholstery material and utilitarian objects.

Patchwork takes on another mood when a different kind of fabric is used. This playful *kasuri* carp jumped out of a store window and into Paul Ruig's room, because it echoed the tones of his "Indonesian" print quilts from the China Seas fabric collection. The match, as it turns out, is not coincidental, since *kasuri* has its origins in Indonesia.

NOREN

To the experienced visitor, the very word *noren* evokes images of quintessential Japanese scenes, complete with paper lanterns, blue tiled roofs and dark wooden buildings.

These doorway curtains, hung in front of shops and restaurants, function as signs announcing the speciality within. They are generally made of several one-foot wide pieces of material seamed part way along their length, so that the customer can part the flaps to pass through. If they are not tucked out of sight but fluttering in the wind, the restaurant is open. While serving a commercial function, *noren* are reminiscent of bunting to the Western eye and lend a festive air to the street.

From the late 16th century to the early 18th century, *noren* simply bore a picture of the store's product. As the rate of literacy increased, the picture

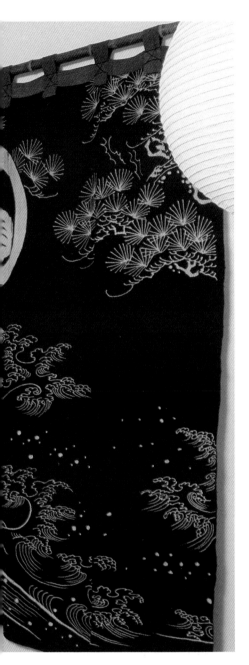

LEFT: A 19th century ceremonial *noren* with an oak leaf family crest greets visitors with a flourish in the foyer of a 50-year-old home. The oak was believed to be the home of the dieties that protect forests, and the crest became popular with samurai, particularly those who were devout followers of Shintoism. The design was done freehand in wax resist on indigo-dyed linen.

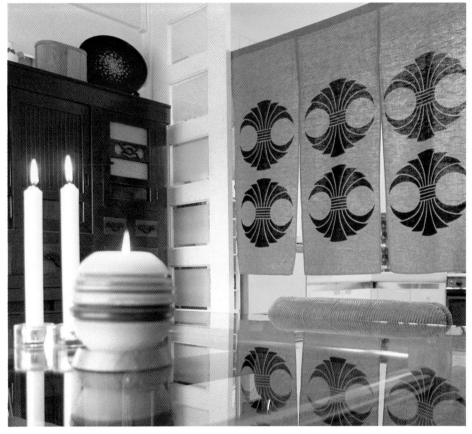

was replaced by *kanji* inscriptions.

Less familiar to the outsider are elaborate, antique *noren*, which used to be hung in front doorways of homes for weddings or funerals or within the house to separate one section from another. Many of these were made of silk or linen in handsome designs. Sometimes they were part of the bride's trousseau and hung at the doorway of the newlyweds' room.

ABOVE: Modern *noren*, used to separate areas within Japanese homes, are equally effective in Western homes. This apartment lacked a door between the kitchen and the dining room. Cindy Gastonguay's solution turned the deficiency into a bonus.

RIGHT: A splendid quilt cover from the early Taisho era (1912–1926) is an impressive feature of Barbara and Pieter Ruig's living room. Its traditional symbols for happiness and long life suggest that it was a *futon* cover for the bride whose pine family crest it bears. The crane is said to live 1,000 years; bamboo symbolizes resiliance. The pine connotes fidelity, since even when its needles fall to the ground, they are still paired. The hardy plum, blossoming even through the snow, suggests vigor.

BELOW: A smaller quilt cover, probably meant for a baby, is thought to be late Meiji or early Taisho. The family crest is a blossomed paulownia. Originally, the paulownia and the chrysanthemum were imperial crests, but they were conferred upon several military leaders and feudal lords, who used them for generations. Mrs. Ruig's professional touch shows again in this elegant grouping. Her design studio, Barbara Ruig Interiors, is well known in both Chappaqua, N.Y. and Philadelphia.

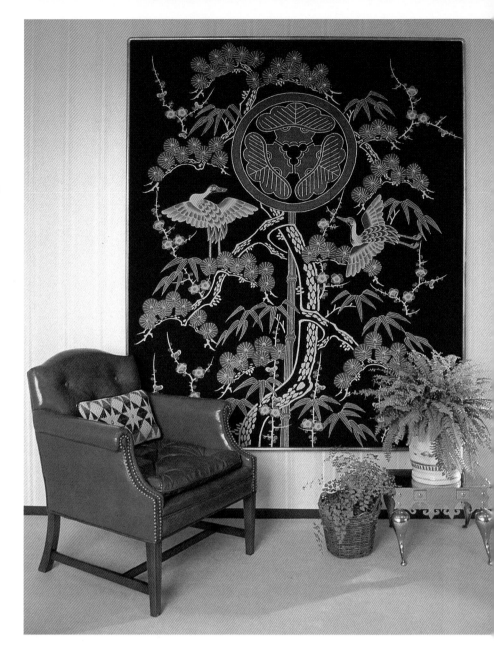

QUILT COVER

Another appealing country textile, the quilt or *futon* cover, can be used as a wall hanging that complements many kinds of decor. *Futon* is the thick comforter used for sleeping on *tatami* floors. Fine examples of *futon* fabric, dating from the turn of the century, can still be found at shrine sales and antique markets.

Futon covers (*futonji*) were often produced by a method highly developed in Japan: resist dyeing. In this technique, a resist is applied to the cloth to prevent desired parts from taking up the dye. Sometimes wax is used, but a starch resist paste (*nori-zome*) is more common. The paste is made from glutinous rice and designs can be applied either freehand (*tsutsu-gaki*) using a pastry cone-like tube, or by stencil (*kata-zome*). *Tsutsu-gaki* permits more design freedom and is used chiefly for large patterns of banners, *noren* and *furoshiki*

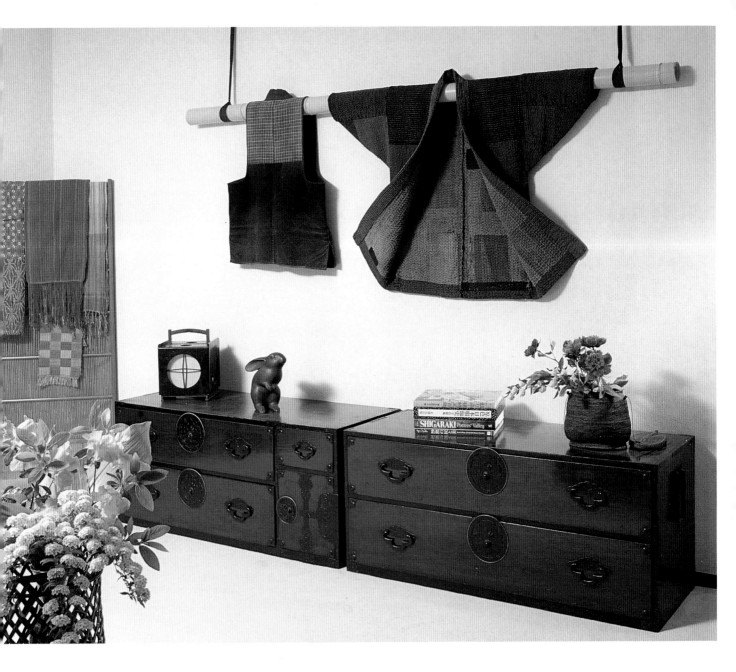

SASHIKO

Work clothes may look unappealing piled in stalls at outdoor markets, but a closer look often reveals another cherished folk art: *sashiko*, Japan's form of quilting. Quilting, a decorative way of patching and strengthening, derives from a way of life in which cloth cannot be wasted.

Sashiko techniques flourished in Tohoku and Hokkaido, the only regions where cotton could not be grown and where the long confining winters gave the women time for needlework. *Sashiko* stitches are very tiny and placed in tight rows, giving an aged garment an almost leathery look. Women of the northern regions have been known to make ten such jackets before their marriage, enough to last their farmer or fisherman husbands a lifetime.

ABOVE: Display is paramount as humble indigo-dyed *sashiko* work garments, no more than 50 years old, dramatically enhance an apartment living room. Their discoverer, Nancy Ukai Russell, a Japanese American writer, spent a year living in a Japanese temple studying weaving and dyeing. The timeless manner in which they are hung mirrors the way the Japanese still use bamboo poles today to suspend everything from laundry to designer fashions.

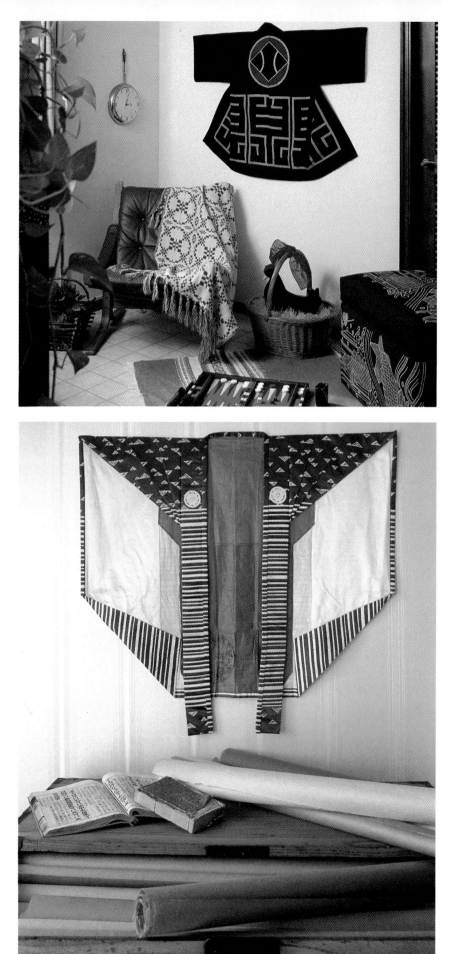

The modern design of this cotton *hanten* or *happi* coat belies its antique origins. A *hanten* is the blue collar worker's indigo-dyed jacket. Different trades and companies commission the dyeing of their own designs. This coat's geometric border motif is made by the repetition of a single *kanji* and the circle is the company's logo. The garment adds its interesting design to Rochelle and Bruce Narasin's family room. *Hanten* are still used by some trades today, so they can be purchased new or antique.

Sara Hostelley's affinity for textiles and handmade papers is exhibited in this wall hanging, a cotton and paper garment called *kamishimo*, worn by musicians at the Kabuki theater. The shoulders have concealed stays to give the wearer a broad-shouldered look. The garment comes from the samurai, who wore *kamishimo* on full-dress occasions.

Wood

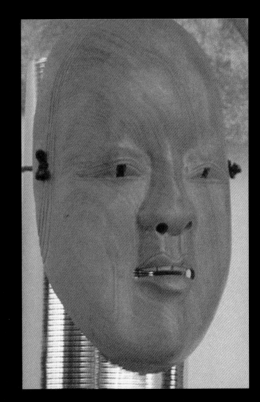

With about 70% of Japan's total area forested with many different species of trees, wood has been a prime material for construction and household articles since the eighth century. A heritage of respect for wood is shown by the fact that 66% of the wooded area consists of planted forests, mostly cedar, cypress and pines.

Japan's history of fine craftsmanship reached its peak in the period between the 17th and 19th centuries, with a variety of home furnishings. Most of these forms had simple lines with an emphasis on verticals and horizontals that coordinated with the unadorned traditional interior.

This chapter presents several different wooden objects, starting with the evocative Nō mask. Exacting skill is necessary to carve one, since it must suggest changing emotions as the actor inclines his head. Nō

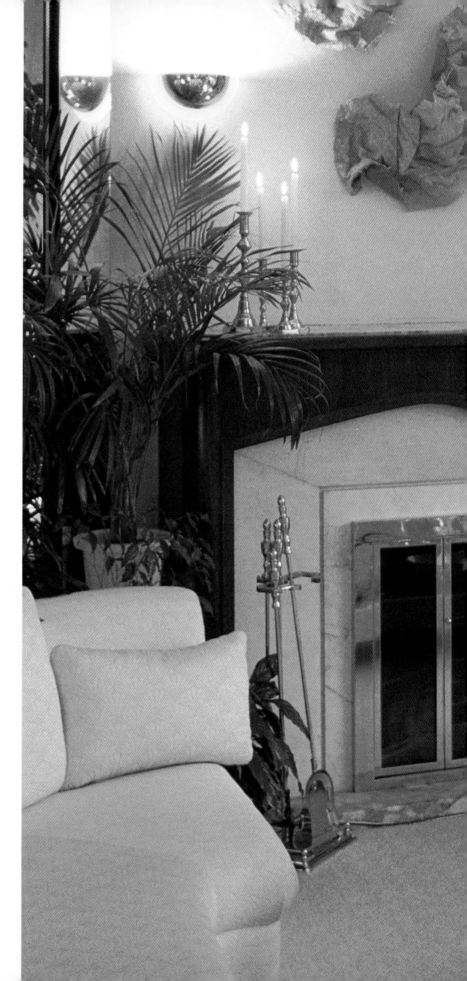

Joan Shepherd bought a reproduction of a Nō mask when she first came to Japan twenty years ago. She resourcefully made a pedestal for it by wrapping gold paper around a cardboard tube. Although her living room has been redecorated many times since, the riveting Nō mask continues to perform. Bill Pratt's pulp art over the mantel is flanked by 10-foot mirrors, mounted on folding screens.

masters are smaller than lifesize, so the actor can see through the nostrils as well as the eyes when the mask is worn at a slight distance from the face. The smaller size is also traceable to an ancient Chinese definition of beauty, which said the head should be one-eighth a person's height.

OPPOSITE: A farm door becomes an artist's desk. A furniture restorer made the drawers, adding traditional Japanese hardware. Sara Hostelley, a textile design artist, who worked under the name Sally Hostelley in the U.S., acquired the wall hanging in Takayama. It is a contemporary quilt made from antique stencil-dyed fabric (*kata-zome*) by Horoko Souichi.

ABOVE: A richly appointed *keyaki* door, estimated to be 100 years old, is turned into a massive coffee table in the home of Nancy and David Gates, who also utilize a glass-topped door as a dining table.

VANITIES

At outdoor markets, vanity tables or *kyodai*, often look as if they belong in a little girl's room for dress up play. They were actually an important part of every woman's toilette during the Meiji period (1868–1912) and were widely produced until the end of the Taisho era (1912–1926). A woman sat on the floor in front of the tiny mirror to prepare for the day and extracted her hair ornaments, powders and oils from the small drawers. When she was done, the vanity was put away out of sight.

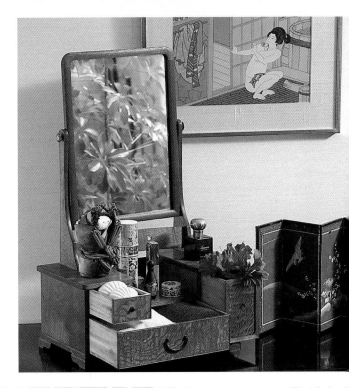

THREAD SPOOLS

Occasionally, complete reeling wheels appear at outdoor markets, but more often only the thread spools remain from Japan's hand spun silk era. Until the turn of the century, women and children labored long hours unraveling silk worm cocoons onto these wheels (*ito-maki*). The spools—they actually are not round—come in many different sizes. Grouped together, they make attractive pedestals for candle sticks or plants.

SWEET MOLDS

Another plentiful and inexpensive item on the market is the wooden mold for sweets (*kashi-kigata*). Mixtures of basically sugar and flour are pressed into it and allowed to dry. Molds are usually made from mountain cherry wood, 70–100 years old. Before the wood is carved, it is dried for five years to prevent cracking.

OPPOSITE ABOVE: Dianne and Don Schultz came across this vanity at an outdoor market. Although it was covered with grime and cost very little, Mrs. Schultz saw its promise. Now, its drawers proffer soaps, perfumes and towels to 20th century guests.

OPPOSITE BELOW: In this arrangement of thread wheels, Peggy Stauffer uses contemporary earthenware pots as planters. They are called *kamameshi*, named after the special rice dish served in them.

ABOVE: All sorts of designs are used for sweet molds. The red snapper form, shown with the fan mold in Rochelle Narasin's kitchen, is used for ceremonial occasions.

SMOKING BOX

Europeans brought tobacco to Japan in the 16th century, and by the 18th century both men and women enjoyed pipe smoking. Tobacco boxes, *tabako-bon*, were developed in the late 19th century for homes, restaurants and shops. Although crafted in varying degrees of luxury, each had two essential components: a small receptacle to hold burning charcoal to light tobacco and a short length of bamboo, used as both ash tray and cuspidor. Tobacco boxes became obsolete when cigarette smoking took over at the beginning of this century.

STEP TANSU

The step tansu or *kaidan dansu* is a free-standing staircase chest used to reach the loft in old houses and shops. Curiously enough, built-in staircases didn't exist in former times. Rural houses were largely one story and even in the taller dwellings designed for silk worm cultivation, ladders were used to reach the upper floors. Step tansu began to make their appearance in the late Edo period (1603–1868), and because interior space was limited even then, drawers were constructed under the steps of these staircases. Since a great deal of wood was required for their construction, step tansu were not usually made of expensive hardwoods, except for the drawer fronts and cabinet doors.

ABOVE AND FRONTISPIECE: A beautifully grained, *keyaki* smoking box is handsome enough to serve as a centerpiece on a dining table. A Kutani porcelain dish holds flowers, while a young man of Royal Copenhagen china languishes approvingly.

OPPOSITE: A small step tansu becomes a graceful room divider in Susan and Steven Geffen's Tokyo penthouse. Mrs. Geffen, whose interior design company, Sandstrom-Geffen Enterprises, Ltd. is in Armonk, N.Y., finds that most step tansu are too massive for normal-sized rooms. This particular chest staircase is a shopkeeper's model, which was pushed out of the way at night. The back has been refinished to match the front.

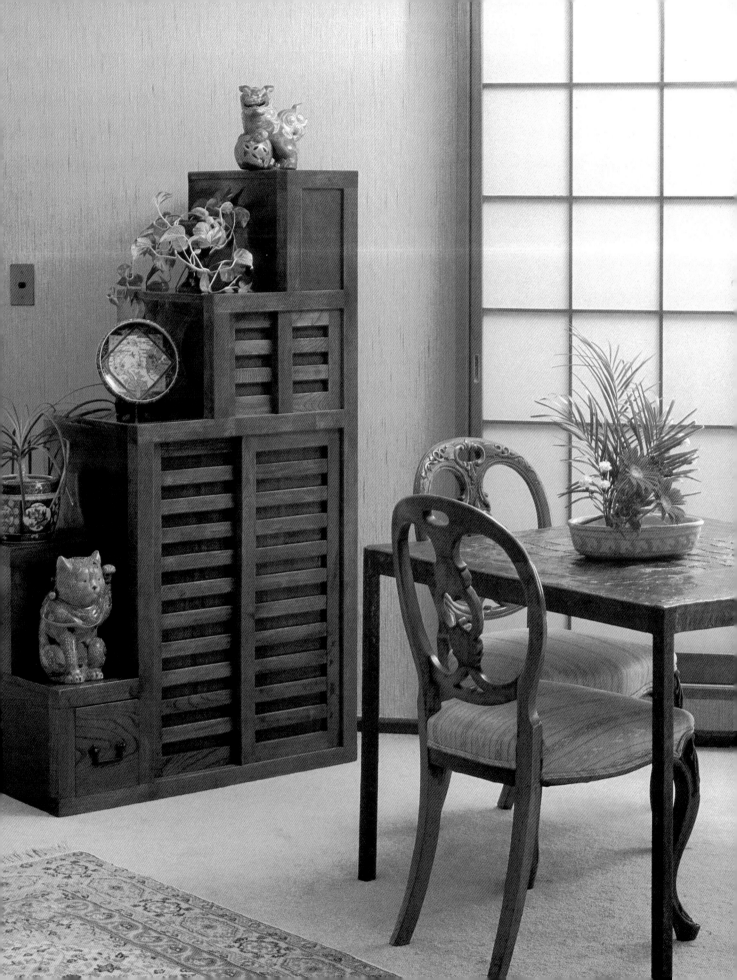

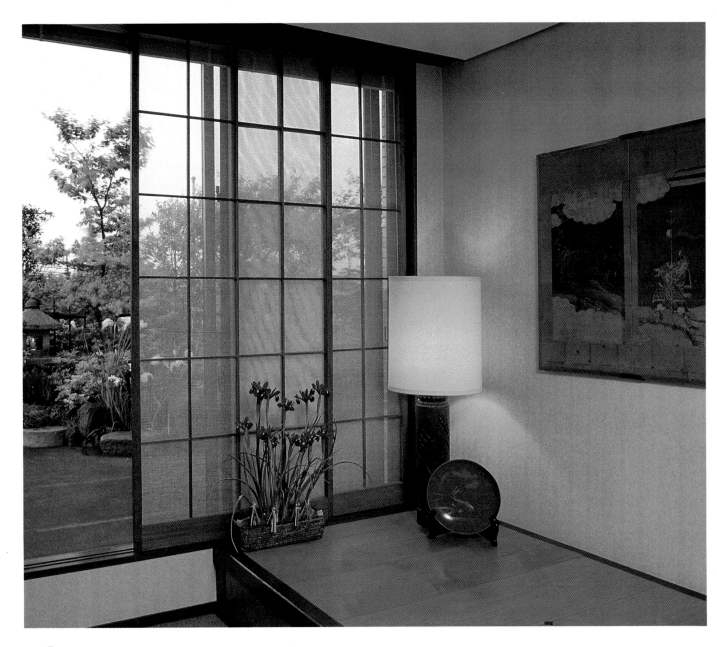

SHŌJI

The translucent sliding doors of Japanese architecture have long been familiar to the outside world and are readily incorporated into other lifestyles. Their paper panes block out unpleasant views or reveal graceful ones in greyed silhouettes. The long fibers of *shōji* paper actually diffuse the light so that the room is illuminated in a distinctly different and softer way.

Shōji were born in the pre-glass era when a partition was needed to admit light but not drafts. The *shōji* paper "breathed" during the summer permitting ventilation, but kept heat loss to a minimum in winter.

Kogi Yagi in his book, *A Japanese Touch for Your Home*, presents excellent photographs showing the versatility of *shōji*. We, however, in collecting instances where Japanese designs are used in unexpected ways, offer in this chapter three inventive applications of the *shōji* concept.

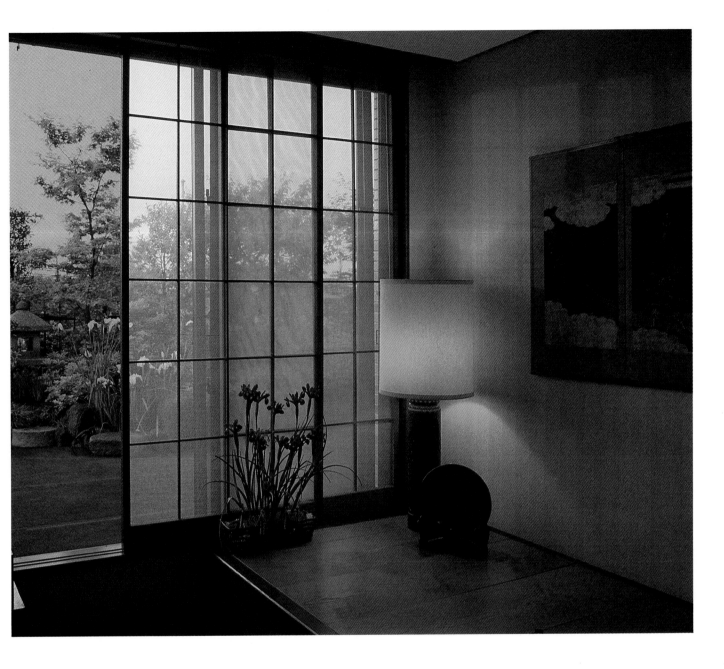

Miki Hasegawa and Steve Parker
found that their narrow living room
was further diminished by an expanse
of *shōji* screens. Even when open, the
shōji blocked part of the garden from
view. Mr. Parker, a theatrical producer,
came up with a theatrical solution. He
replaced the *shōji* paper with scrim, a
gauze-like fabric used as a see-through
curtain for special stage effects. The
effect on their apartment is equally
dramatic. The garden is on view day
and night in atmospheric soft focus.

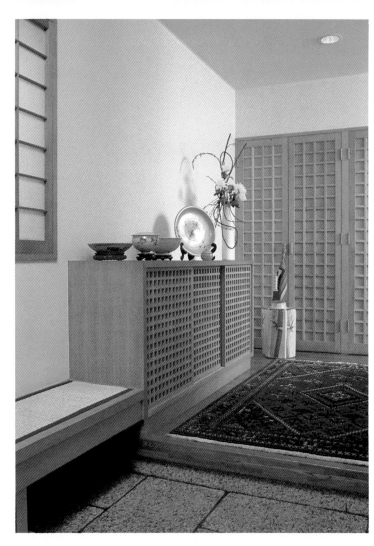

Suzette James played several variations on the *shōji* theme in designing the foyer of her Tokyo villa. Although her architecture is Western, she wanted to connect the entrance way with the Japanese garden outside. The *shōji* design is rendered in various woods and sizes on the front door, the shoe cabinet and the closet doors. The front door treatment, Mrs. James says, is typical of *sushi* bars. The foyer also displays Mrs. James' *ikebana* skills and contemporary ceramics from her native South Africa.

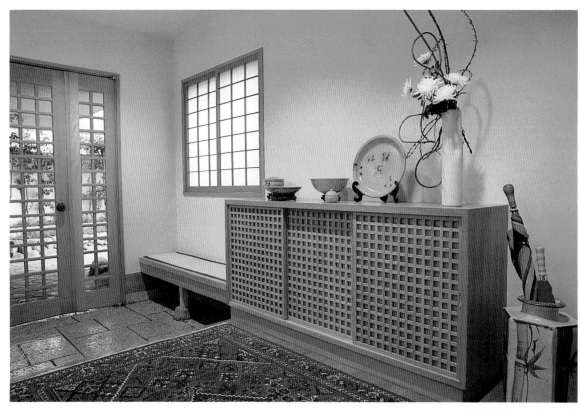

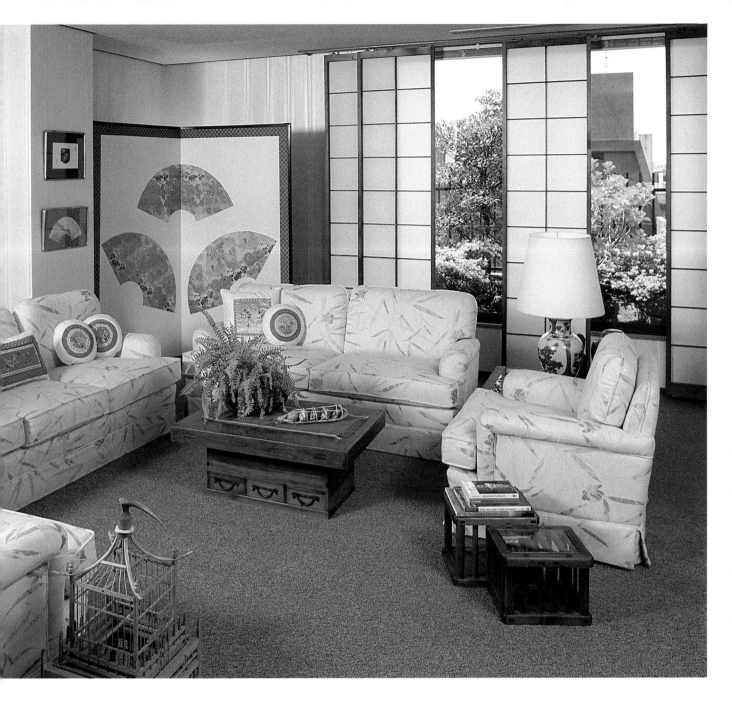

Sara and Ken Hostelley also cherish uninterrupted views and *shōji*. Mrs. Hostelley found a way to have the best of both worlds by suspending *shōji* from parallel ceiling tracks. Instead of having half the window blocked by open *shōji*, none of the view is lost, since the four panels slide all the way past the window, one behind the other. There are no floor runners to damage wall-to-wall carpeting.

The standing screen is Sara Hostelley's original creation. Using some of the traditional components of screens—the black laquered frame, seven layers of handmade paper, and silk borders—she has recreated a classic Japanese theme of fans with an untraditional medium: a brocade obi. Small *kotatsu* end tables and a Chinese birdcage share the foreground.

RANMA

Since the roofs of Japanese wood frame houses rest on pillars, the interiors are not restricted by fixed load-bearing walls. Instead, opaque partitions called *fusuma* are used. These can be removed easily when a larger room is needed. *Fusuma* are essentially *shōji* grids covered on both sides with either heavy paper or cloth. (They were often decorated with beautiful paintings.) Their standard height is about six feet, which leaves a gap between the upper runner and the ceiling.

The gap was filled by a carved wood transom, a *ranma*,

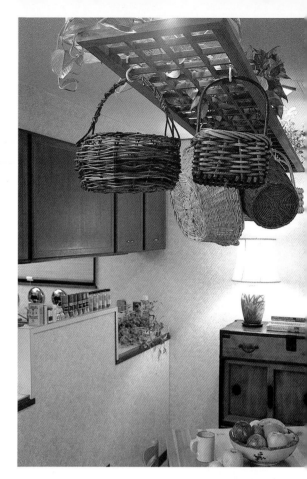

OPPOSITE ABOVE: A *ranma*, found in the back of an antique shop, becomes an artificial ceiling in a kitchen, diffusing the bright light over the breakfast table and providing a touch of greenery. The collection of baskets adds a rustic touch to an otherwise sterile kitchen.

BELOW: In a small powder room, a strategically placed *ranma* becomes a *trompe-l'oeil* window, giving an illusion of spaciousness. Claire Marchessault then added mementos from Cape Cod for further subliminal refreshment.
OPPOSITE BELOW: Ronna and Keith Pandres bought this unusual *ranma* of Mt. Fuji at a store in the Aoyama section of Tokyo. When they cleaned it thoroughly, they discovered that Mt. Fuji was rendered in its original conical shape, not flat-topped. Certainly, a find that deserved special display.

in either latticework or a free-form design. The carving was meant to be admired from both sides, and in the dark days before electricity, the moving sunlight projected its design about the room.

Fortunately, these finely carved planks are being removed from old homes before the wrecker's ball strikes and occasionally can be found laden with dust in corners of antique shops.

ABOVE: An interior transom, a *ranma*, depicting a mountain lion about to pounce, becomes a natural focal point in this sleeping alcove, although Susan Geffen's cat wanted to share the honor. Flanking the *ranma* are a pair of bamboo blinds, *sudare*, which were hung either outside the window or at the edge of the veranda in old houses. Their fine bamboo reeds permitted those inside to see out, while no one could see in. These *sudare* are approximately 35″ wide and come in various lengths.

SCREENS

The flexible Japanese interior utilized many kinds of free-standing screens to create privacy, define an area or deflect drafts. Gilded folding screens, so prized for their silk paintings, were originally positioned on interior walls to reflect sunlight and increase light in dark old houses. Simpler screens of bamboo, rush, *shōji* and wood were movable walls, separating sleeping areas or entrance ways. These screens are just as useful in twentieth century homes to conceal, decorate, or sometimes deflect traffic.

BELOW: For the first time in many years, Joan and Vito Ninivaggi found themselves in an apartment without a family room. The TV that had been banished to other quarters was back in the living room. A bamboo screen from a shrine sale disguises it nicely while making a positive contribution to the room.

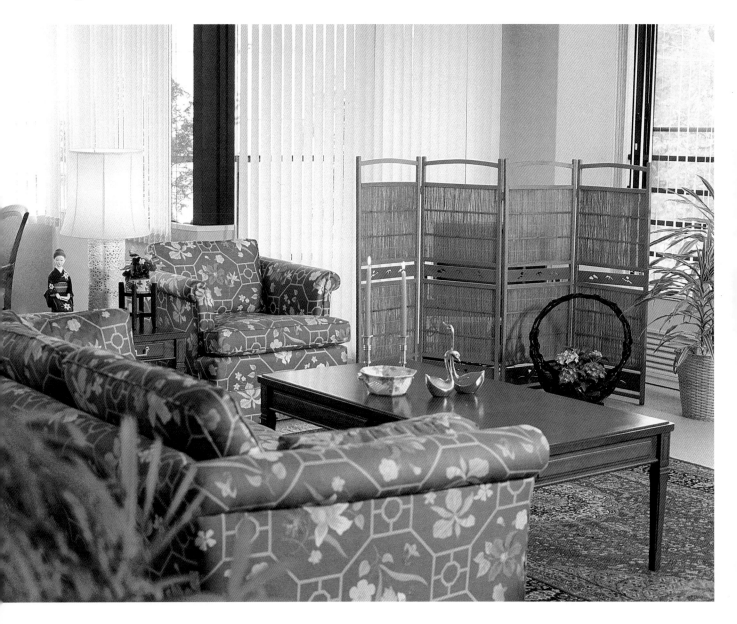

RIGHT: In summer, *shōji* screens were replaced with a cooler version made of rush. Barbara Ruig found this one covered with cobwebs and unfinished in an antique warehouse. Now stained a rich walnut, it serves as a unique window treatment, which gives privacy as well as light. Sometimes during parties, it is positioned in the hallway to screen off the children's wing. The planter is a lacquered *hibachi*.

BELOW: Another bamboo screen is a logical room divider between the living and dining areas of Sheila and Bud Rosenthal's eclectic apartment.

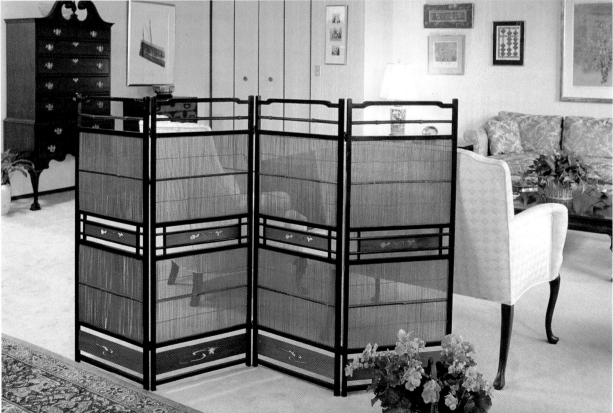

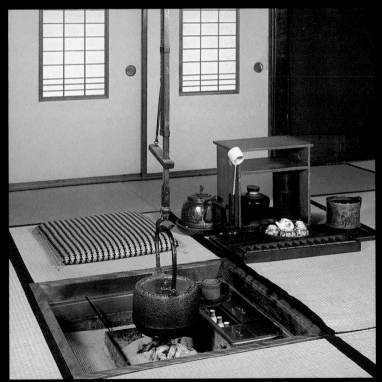

It takes a while for the Westerner to realize that the cup of green tea that materializes on his arrival in a restaurant is much more than a cup of tea.

Green tea equals hospitality, meditation, comfort, aesthetics. The tea ceremony itself, which is a highly ritualized way of preparing powdered tea and serving it, provides an escape into a world of natural materials, refined movement, and peaceful relationships. Every movement of each participant is prescribed, and talking is strictly forbidden.

The tea ceremony came from China with Zen Buddhism and grew in popularity until it became a display of luxury by the wealthy. In the late 15th century, three tea masters urged a retreat from the conspicuous wealth associated with it. The most famous master, Sen no Rikyu, started serving tea in a very small room with accessories made of humble materials. His precise ritual, an exercise in mental relaxation and aesthetics, has been followed ever since.

Although iron was not plentiful in old Japan, iron was preferred for ulititarian hearth pots and tea kettles. Various locales became famous for their kettles, some with elegant smooth designs and some with unpretentious rough surfaces. And of course, beautiful teapots continued to develop in porcelain, stoneware and pewter.

In old rural houses, cooking was done over a sunken hearth (irori), a square hole in the room for burning wood or charcoal. Tea kettles and pots were suspended over the fire from a hook on a wooden pole (jizai-kagi) attached to a ceiling beam. The height of the kettle could be adjusted through a pulley mechanism threaded through a horizontal balance.

These stabilizers became the object of elaborate decoration in the simple homes devoid of much adornment. Fish and other motifs associated with water, the antithesis of fire, were chosen for good luck against uncontrolled fire, Japan's biggest nemesis.

OPPOSITE: A flower arrangement is an integral part of every tea ceremony. Its container must be decidedly simple like all the other aspects of the tea ceremony. Susan Geffen set her Western tea table under a bronze crescent container designed for tea ceremonies. Even without flowers, silhouetted against the shōji, it lends quietude. The tea service is West German; napkin rings, Chinese cloisonné.

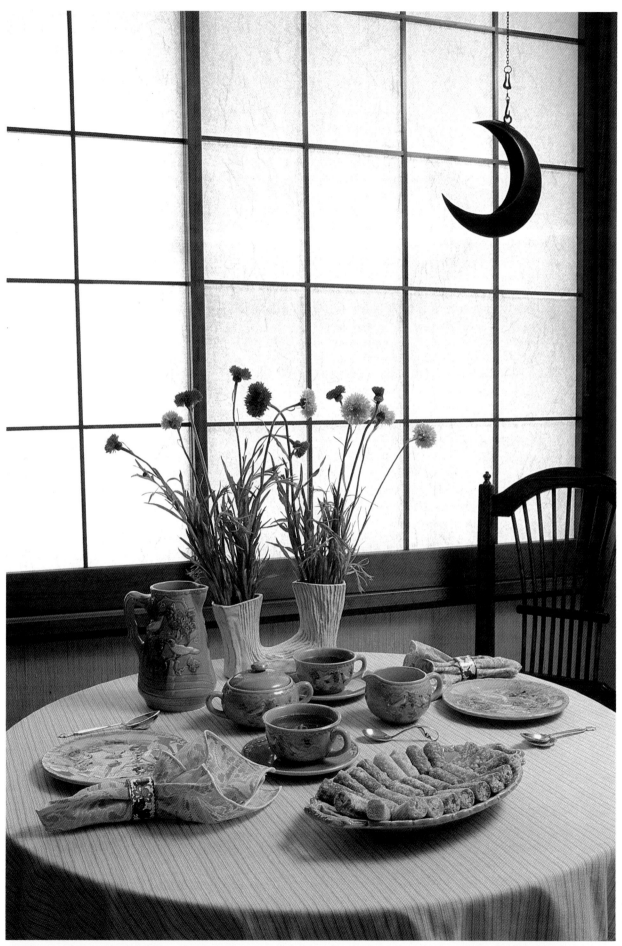

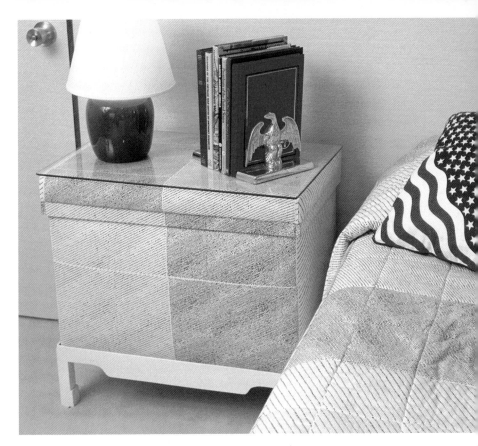

RIGHT: Barbara Ruig chose to use
her son's bedspread fabric to
transform a pair of *chabako* into night
stand/storage units. A local
woodworker built platforms to bring
them up to bedside height.

BELOW: Tae Young Park decided to
handpaint a tea chest. She coated it
first with white and then used
watercolors to recreate the design of
one of her favorite Gucci scarves.
Before giving it a final coat of varnish,
she added the date, a touch which
gives it the look of an antique Alpine
dowry box. The bedspread is by
Missoni.

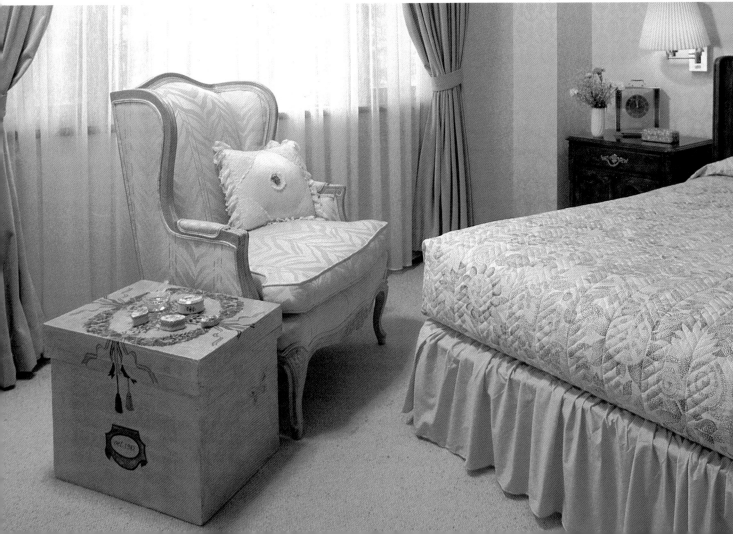

As old houses are torn down, homeless *jizai-kagi* stand waiting for new hearths and new roles such as holding baskets or plants.

Because tea is a central aspect of daily life, every tiny neighborhood in Japan today has a tea store selling countless varieties for home consumption. The shop receives tea in large wooden, tin-lined containers. These empty tea boxes, *chabako*, turn out to be versatile storage chests in Western homes, providing additional protection against moth, mildew and basement flood waters. They go to work in every room in the house, covered in many different kinds of material, to hold clothing, blankets, craft supplies, toys, photo albums, and even files.

A tea box may be covered in much the same way as a window valance by stretching fabric over a layer of batting. *Chabako* come in many sizes and can be purchased directly from a tea shop. Some specialized gift stores have them already covered.

ABOVE: While *yukata* fabric is probably the single most popular material used to cover tea chests, Susan Geffen chose a simple monochromatic cotton and then added a woven silk obi for an interesting textural effect. The chest rests on an Indian carpet with a Tabriz design.

LEFT: Cindy Gastonguay has capitalized on the rich colors and texture of a silk obi by using it to turn a utilitarian tea chest into a sophisticated living room ottoman.

TOP: Pat Murray's kitchen window sill becomes a display case for her collection of miniature iron tea kettles, found at shrine fairs. Iron is said to improve the taste of green tea by drawing out its subtle flavors.

BOTTOM: Retired from active duty, this antique iron tea kettle, glowing with the patina of service, is content to brighten a veranda with a gentle spray of flowers.

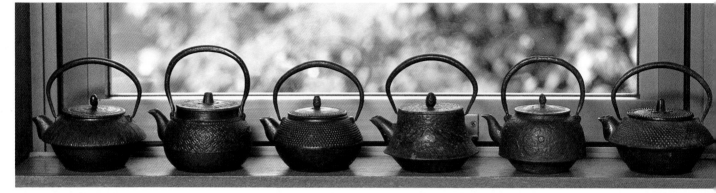

Saké

Saké is one Japanese institution that shows no sign of dying. As old as the hills, saké was a nobleman's drink two thousand years ago. It was born with the introduction of wet rice cultivation in Japan in approximately 300 B.C. and by the end of the 12th century, it was enjoyed by the masses. Some 2,700 breweries produce refined saké in Japan today.

Virtually a national drink, saké is a brew of fermented rice, yeast and very pure water. It plays an important role in Shinto religious ceremonies, on formal occasions, and just about every other occasion that calls for a drink. With an alcoholic content of about 32 proof, saké is usually served warm and comes sweet, dry, light, heavy and aged, although it is rarely stored for more than a year.

Serving vessels and carrying casks, both modern and antique abound, from oversized, lacquered, ceremonial cups to oddly shaped flasks for picnics. Saké is the preferred beverage for the elaborate parties

BELOW: Mrs. Ruig was out jogging early one morning when she spotted this empty keg, beautifully fresh, waiting for the sanitation department. Her son was happy that she struggled home with it—they are actually not very heavy—since he was the recipient of a new bedside table for his magazines.

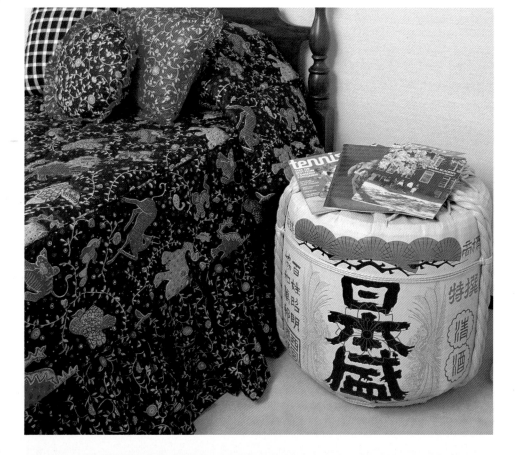

connected with cherry blossom and maple leaf viewing, watching the full moon or falling snow.

All sorts of areas of life have been touched by saké. Lea Baten points out in *Japanese Dolls* that the three ladies-in-waiting in the *Hina* Doll set carry the saké implements still used at Shinto marriage ceremonies. And the three serving men in the set "show by their expressions the three different effects of over-indulgence: happiness, sadness, and anger."

A favorite "artifact" among Westerners is the ceramic jug with a bamboo-wrapped handle

BELOW: Margot Burton's sense of humor enlivens a corner of her living room with an informal touch. She took a saké keg and simply pulled off the entire top to acquire a gigantic and colorful planter. Think how many Lego bricks a barrel this size could hold!

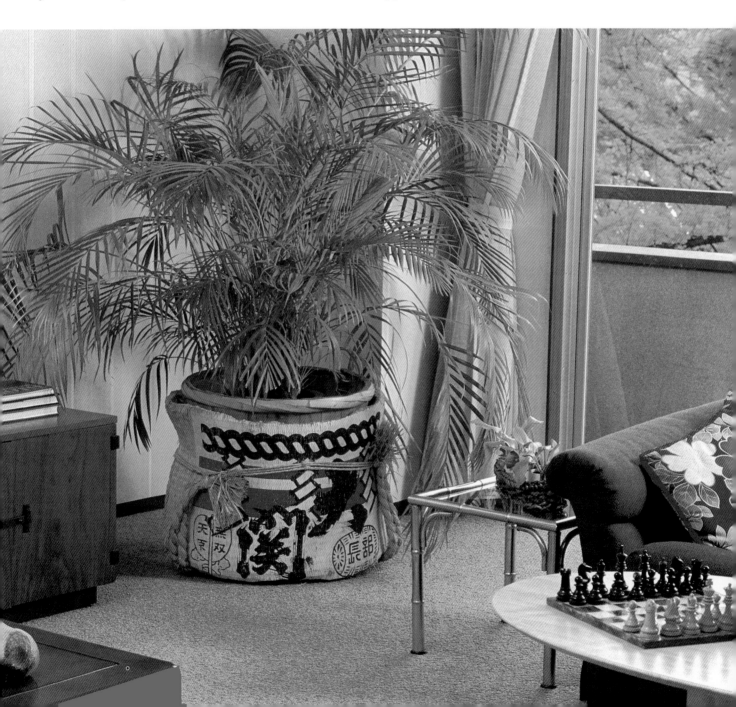

A small saké keg/lamp sheds its circle of light on a collection of Japanese stoneware in Joan Shepherd's guest room. The drawing by Lynn Sturm Levy rounds out the Western perspective.

A saké jug is recycled as a lamp in this U.S.-Japanese blend. Barbara Ruig wanted to create a distinctly American room in her apartment, so she bedecked the study in red, white and blue. The saké jug steals the show in this charming corner.

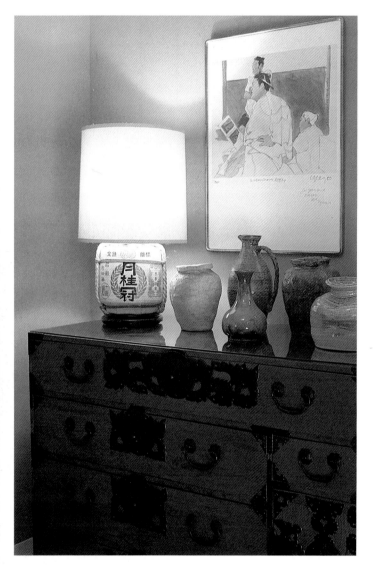

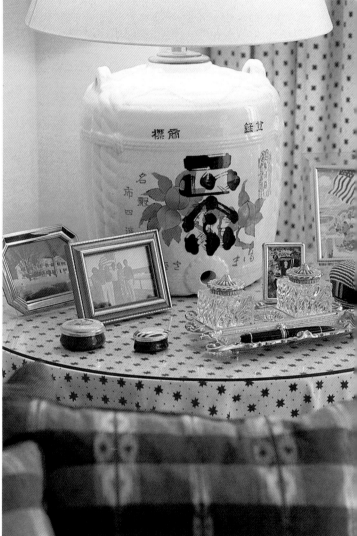

that dispensed draft saké in shops until the 1940's. Homeowners came with smaller earthenware bottles and refilled them with their favorite brand. The jugs make handsome accent pieces in themselves or sturdy lamps. The slender bottles are also readily turned into lamps or vases. Today, restaurants receive saké shipments in large straw-covered cypress kegs, *komokaburi*, which are often displayed outside the establishment. These empty barrels can also be seen lined up outside Shinto shrines, an advertising privilege accorded to companies that donate saké for ceremonies. Since their *kanji* advertising is not discernible to most foreigners, these playful kegs turn into conversation pieces in international homes.

Clothing Stands

The kimono stand, *iko*, is another item that lends itself to dual citizenship.

In one Tokyo apartment, the foyer lacked a coat closet, so the resourceful tenant equipped it with kimono stands, purchased inexpensively at the Heiwajima Fair. Since the stands are meant to hold delicate silks, they are always finely finished and often lacquered, so items placed on them will never snag.

The *iko* was originally created to allow the Japanese woman to drape one or several folded kimono while deciding on the colors and patterns of her ensemble. After all, she didn't have a bed to arrange things on while coordinating her wardrobe.

The crossbar goes through

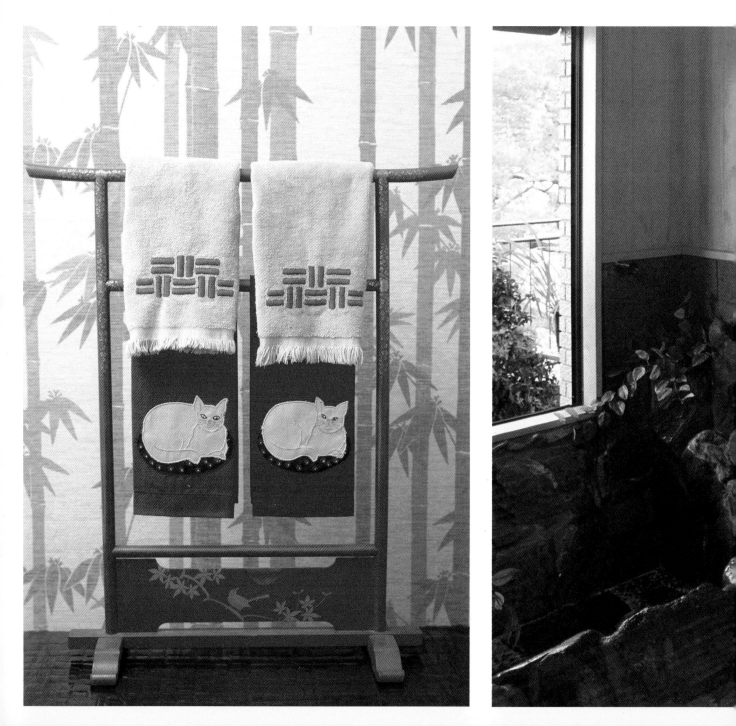

the sleeves to display a single kimono, an arrangement that creates an unusual room divider in a Western home. One could also be used as a screen, displaying an antique bed quilt for a complete East-West merger.

OPPOSITE: A smaller version of the kimono stand, the *tenugui-kake* designed for hand towels, is equally at home in Western powder rooms.

BELOW: After designing this luxurious Japanese bath of native rock for her home, Suzette James added two *objets trouvés* for the finishing touch: a kimono stand to keep towels within easy reach and a small lacquered container for bright flowers.

OPPOSITE: In the home of Angelia and Don Huse, obi are currently serving as an elegant headboard, draped over an antique kimono stand. They are part of a collection chosen for their muted colors and design—all are cranes—which Mrs. Huse will one day use to recover her dining room chairs.

BELOW: Some hand towel stands are hinged to provide even greater versatility in positioning.

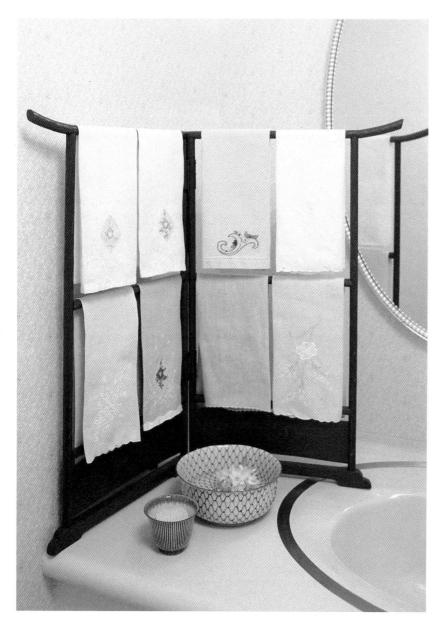

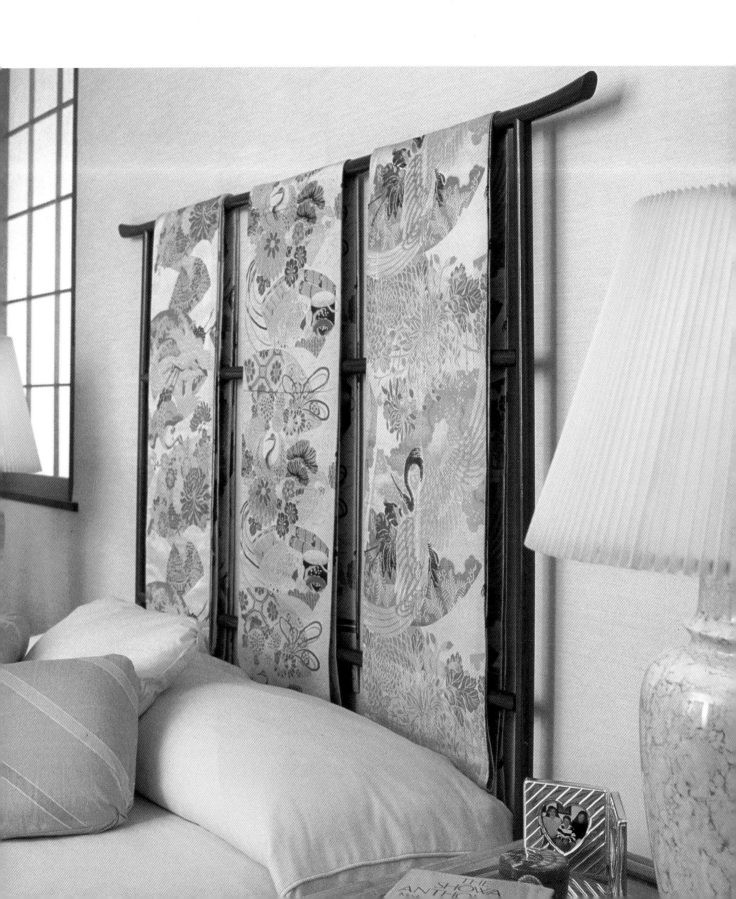

An *iko* provides an original way to
display a prize antique obi in the
home of Ian and Carol Abbott.
Although the three lengths of fabric
came as a unit, beautifully bound
together, hanging it flat against the
wall didn't do it justice.

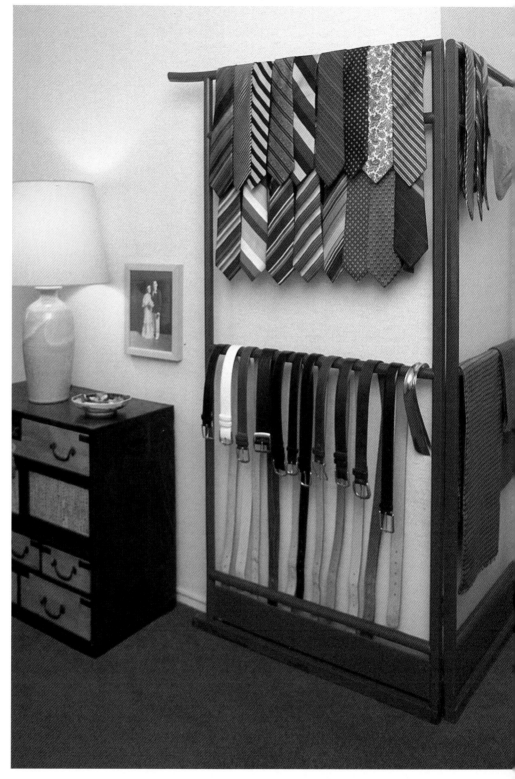

Iko often stood in a corner and sometimes had a little bench connecting the two wings to form a triangle. This stand, too, has found a corner, but probably has never before been wrapped around one.

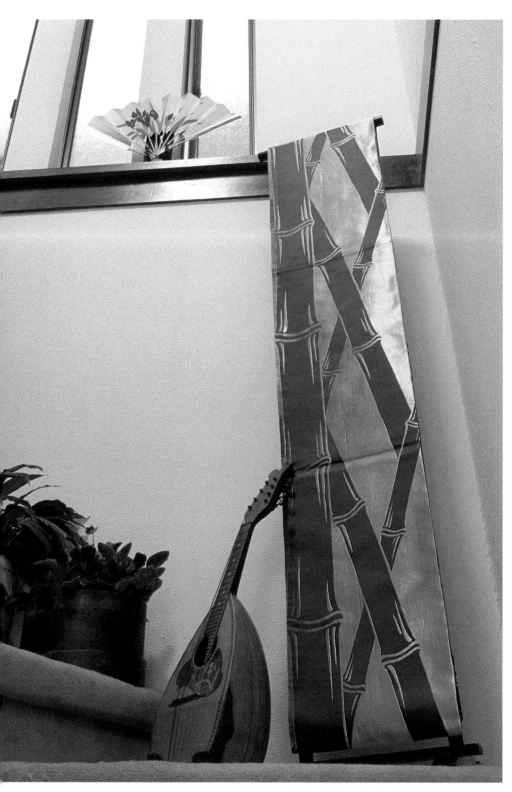

A contemporary obi on an obi stand, lends drama to a stairway landing. Rochelle Narasin's mandolin emphasizes the theatrical effect.

A kimono rack again becomes an appropriate frame for a work of art, a gossamer *noren* of handwoven fabric by a contemporary Japanese craftsman. Returning to the resources of the Jōmon era (10,000–200 B.C.), the artist has used the fibers of the linden tree for his fabric, weaving them in the same open mesh style. He then repeated the indigo dye techniques of a later era and added his own 20th century design to span thousands of years in one work.

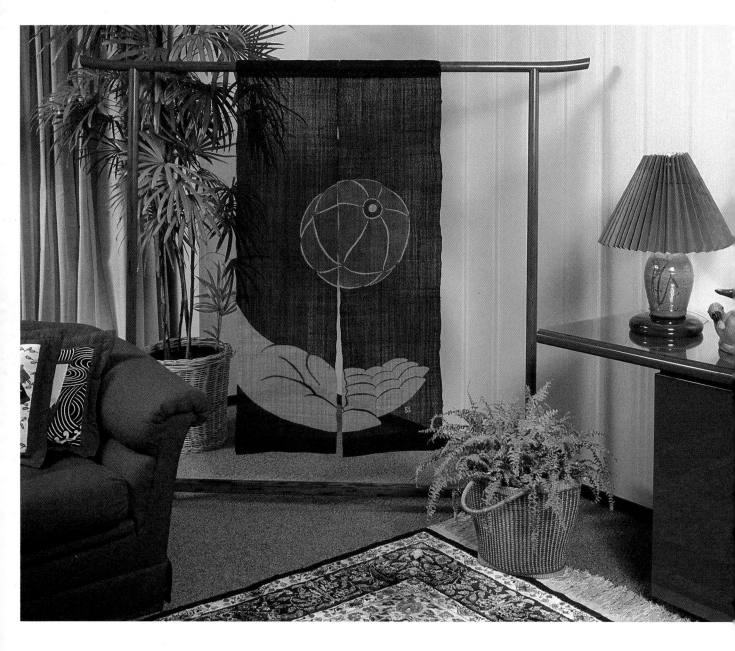

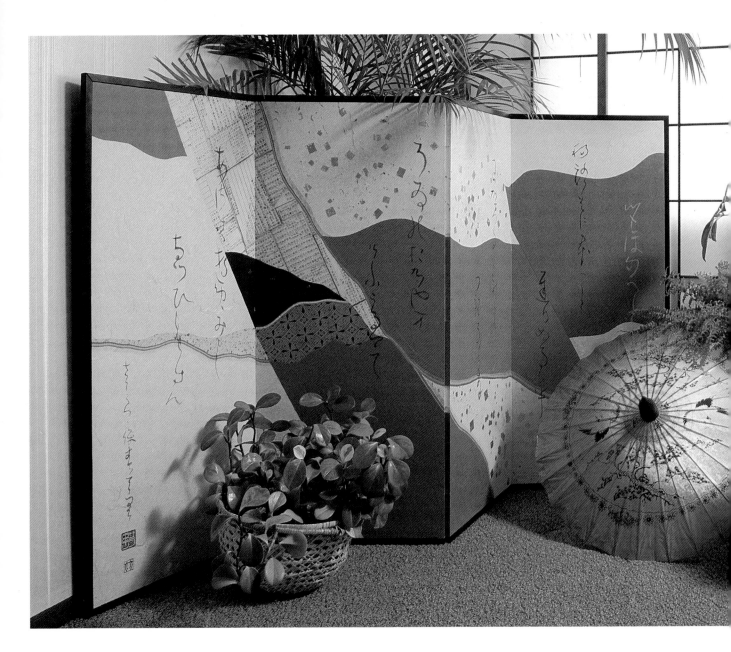

One of the first words a foreigner learns to say in Japanese is "washi." Strictly speaking, *washi* means Japanese paper, but in common usage it refers to Japan's handmade papers, which are acclaimed throughout the world. Japan produces more varieties of handmade paper than any other country.

For decades, the English-speaking West has referred to all Oriental papers, including *washi*, as "rice paper." This is an unfortunate misnomer, since rice has almost no place in Japanese papermaking, except for a poor quality paper sometimes made from rice straw.

Unlike machine-made papers which are made from wood pulp, *washi* must be made from the inner bark of the branches of a live tree. Three different native shrubs are used: *gampi* and *mitsumata*, which produce papers with shiny surfaces, and *kōzo*, a type of mulberry that produces a soft, strong paper.

The strength and durability of these handmade papers cannot

OPPOSITE: The rich properties of Japanese handmade papers have been utilized since Heian times to create an art form known as *tsugigami* or paper joining. Straight edges, torn edges and graduated edges are combined in abstract designs, usually in small dimensions.

Sara Hostelley, however, elected to make a four-panel *tsugigami* screen.

Her ambitious work, decorated with flecks of gold leaf and her own calligraphy, was such a success that she was invited to appear on Japanese television with it. The screen, shown with a Thai paper umbrella, makes an unforgettable statement in the corner of her living room.

ABOVE: Living in Tokyo and surrounded by Oriental scrolls, Sara

Hostelley decided to try a variation. Using very heavy textured handmade paper, designed and produced in Japan and sold principally in the U.S., Mrs. Hostelley has produced a three-dimensional work of art that is at home in any contemporary environment. This avant-garde art form, she says, is gaining momemtum, as paper itself becomes work of art.

be reproduced by industrial methods. These qualities come only as the result of traditional techniques that have evolved over more than a thousand years.

Although mass-produced Western style paper has removed *washi* from most aspects of life in modern Japan, it still plays an important role. Fifty different locations produce the large quantities of *washi* needed for such activities as book publishing, *shōji* production, and artistic folding screens. But *washi* is also essential in the creation of traditional folkcraft items, such as umbrellas, fans and kites. Since these latter objects have slipped from everyday use, they are all the more appealing to Westerners, who are continually finding inventive uses for them and for handmade paper itself.

UMBRELLAS

More than protection from rain or sun, the oiled paper umbrella is another picturesque example of fine craftsmanship.

The artisans who shape the delicate bamboo by hand, perform 20 different operations to create the *karakasa*, which is effective even in a downpour.

Until as recently as the late 1940's, these brightly-colored umbrellas dotted every rainy day street scene.

The concept of the umbrella originated in China, where field workers first held their wide-brimmed hats aloft on a stick for protection. Early umbrellas were silk and couldn't be closed. The present mechanism was devised in the 16th century.

There are many types of paper umbrellas, varying in diameter and length of handle, with larger ones for temple and outdoor tea ceremonies. Generally, those with 50 ribs were for men; 40, for women. Fortunately, thousands of *karakasa* are still made each year.

The umbrella is a romantic symbol to the Japanese, just as the heart is to the Westerner. Lovers' initials are linked romantically beneath the outline of an open umbrella. Light rain, after all, is beautiful in a country where the rice crop depends on it and where many gardens are designed to be best appreciated sparkling with moisture. Westerners in Tokyo discover that opening an umbrella in the house doesn't bring the bad luck the Irish have always feared!

Susan Geffen's houseguests waking up in this bedroom don't have to ask themselves, "Where am I?" One corner proclaims Japan. The panda ponders his collection of Japan's traditional folkcraft, under a paper umbrella and an Italian Tizio light.

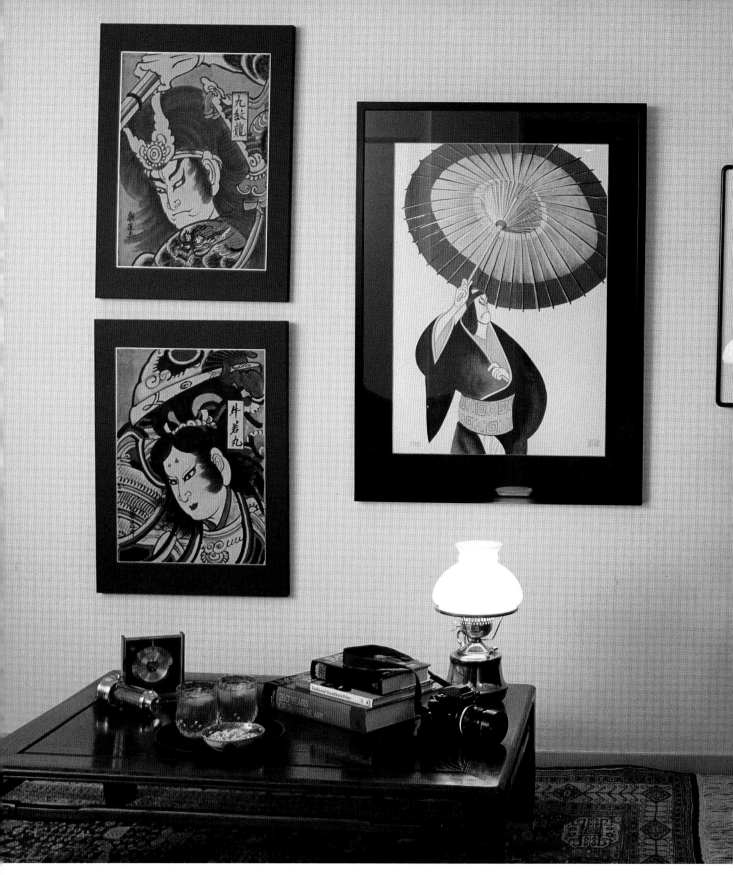

Linda and George Hoza have positioned the work of the famous kitemaker Teizo Hashimoto in their family room along with woodblock prints by Yoshitoshi Mori and another by Al Hirschfeld, known to New York Times readers for his theatrical caricatures. Mrs. Hoza bought the kites before they were put on their bamboo ribs and had them dry mounted.

KITES

The dynamic graphics of Japanese kites deserve more permanent display than a fleeting glimpse in a distant sky. Their designs are hand-painted on *washi* and are often inspired by woodblock prints, *Kabuki* history or the lore of the samurai.

Both Chinese and Japanese warriors used the early kites for signals, carrying messages and even surveillance. Enormous kites carried medieval spies to observe enemy camps. With the Edo period (1603–1868), kites became children's playthings, but adults retained their interest in making bigger and better ones. In 1906, a Japanese team made one of particularly tough *kōzo* paper that was 60 feet wide with a tail of 438 feet and weighed two tons. Some 150 men were required to launch and fly it.

Today various regions compete in battles of giant kites. The tails are studded with small knives and pieces of glass to cut loose the opposition's kites. With smaller kites, the simple friction of string against string can snap the opponent's line and bring victory.

FANS

The fan has been an essential accessory in formal attire of both men and women for centuries. It is a prop in all forms of theater and dance and is even a symbol of authority. Samurai gestured with battle fans made with iron ribs when giving an order. Today's sumo referee still carries a fan. The

color of its tassel indicates his rank in the sports world.

There are two major types of fans, the *uchiwa*, the non-folding type on a piece of splayed bamboo and the *sensu* or folding fan, made of either aromatic slats of wood or paper (*washi*) on bamboo ribs.

The *uchiwa* is thought to have been invented by the Chinese, while the *sensu* is a totally Japanese invention and another instance of crowded Japan's design rule: what cannot be miniaturized, should be folded.

Although a fan is simple in concept, it takes years of experience to learn the precise craft, involving 30 separate processes carried out by as many as six specialized craftsmen. Many different kinds of decoration have been used over the years. Hand-painted ones by famous artists can still be found and are worthy of framing. Many homeowners delight in displaying fans on the small bamboo stands sold with them, but their uses are unlimited.

BOVE LEFT: A children's bathroom
ecomes a colorful folkcraft gallery as
samurai kite glares back at masks,
apier mâché figures, the roly-poly
aruma and two horses from northern
onshu. These square-jawed samurai
iounts were first made in the Meiji
ra by an itinerant woodworker, who
arved them using only an ax and
hisel.

BELOW LEFT: Even the most
innocuous light fixture can become
intrusive. This plastic light box in a
hallway was hidden and softened
simply by folding a piece of white
washi over it and pinning it to the
ceiling.
ABOVE CENTER: One homeowner
used a kite to conceal an unattractive
outlet over her piano, but from the

look on the warrior's face, he may be
concealing more than that.
BELOW CENTER: Large *uchiwa* look
dramatic on a wall, while smaller ones
can shade delicate plants from the
morning sun.
ABOVE RIGHT: *Washi* transforms a
waste basket and a handy tea chest
holding material into a pleasing team
in Cindy Gastonguay's sewing room.

EGGS

A vivid multicolored type of *washi*, similar to origami paper but softer, is used by the Japanese to cover boxes, tea canisters and small trinkets. Carol Croll was covering boxes one day when she thought it might be possible to cover an egg. She had done découpage with blown eggs in the States, so she brought a certain amount of expertise to the task.

Soon after, she perfected the ingenious steps and a cottage industry was born. In two and a half years, Mrs. Croll has covered over 2,500 eggs turning out seamless glass-like eggs with scarcely a loss of pattern. The malleable fibers of the mulberry paper make the smooth skin possible. The final step entails 10 coats of acrylic varnish.

Mrs. Croll's craft, which she has now taught to a great many women, both Japanese and foreign, has become a welcome decorating accent year round.

The special handmade papers used to cover eggs come in a multitude of designs. Many correspond with the colors and themes of the season. Angelia Huse has matched the soothing colors of her sitting room with her patterned eggs in a Korean celadon bowl.

Washi eggs, suspended on fine gold cord, make lasting ornaments. The tree is topped by a *Hina* doll and stands in a Japanese wooden tub that had been discarded on a sidewalk. It was taken home, cleaned up and painted for service in many capacities. The folding screen is an innovation by Maureen Duxbury, who let the muted pattern of handmade papers provide the design. The other side of the reversible screen is a soft blue.

Although the variety of dazzling
papers in a *washi* store can be
overwhelming, Dianne Schultz
spontaneously isolated a single sheet.
She found its striking design worth
framing. The Kutani cat is
unimpressed.

Children's Day

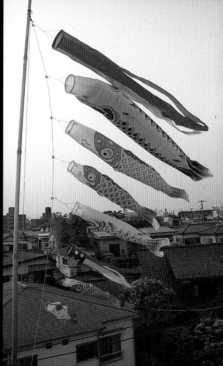

OPPOSITE: A Boys' Day banner solves a decorating problem in this contemporary Tokyo home occupied by a couple with young children and an interest in folk art.

Their all-white stairway walls need a burst of color. They found an antique dealer at a school fair who had a 13-foot banner that looked as it would fit. (Banners come both longer and shorter with widths in the 25" range.) The canvas pole loops attached to two sides were removed, rod pockets were sewn at the ends, and to the particular delight of the children, the stairway was transform

BANNERS

Glowering samurai in various battle poses are the most common design theme for these vibrant Boys' Day banners (*nobori*). They were supposed to inspire boys with the manly virtues of courage and persistence exemplified by the ancient soldiers. Some of the flags portray actual historical heroes.

The cotton banners are usually painted free-hand using a starch resist technique for outlines, or stencilled and dyed with the faces painted in by hand.

Traditionally, the Boys' Festival has been celebrated on the fifth day of the fifth month with Girls' Day on the third of March. Now May 5th has been designated a national holiday and renamed Children's Day, but the emphasis on boys remains. An occasional banner can still be seen flying from bamboo poles in the countryside in early May.

The bold design of the *nobori* and the fact that it is usually reversible permit many imaginative uses in Western interiors. College boys suspend them across dorm ceilings and down walls for a swashbuckling effect. A woman in Virginia has tacked one to the ceiling of her porch. Her family finds the grimacing faces more attractive than perennially peeling paint.

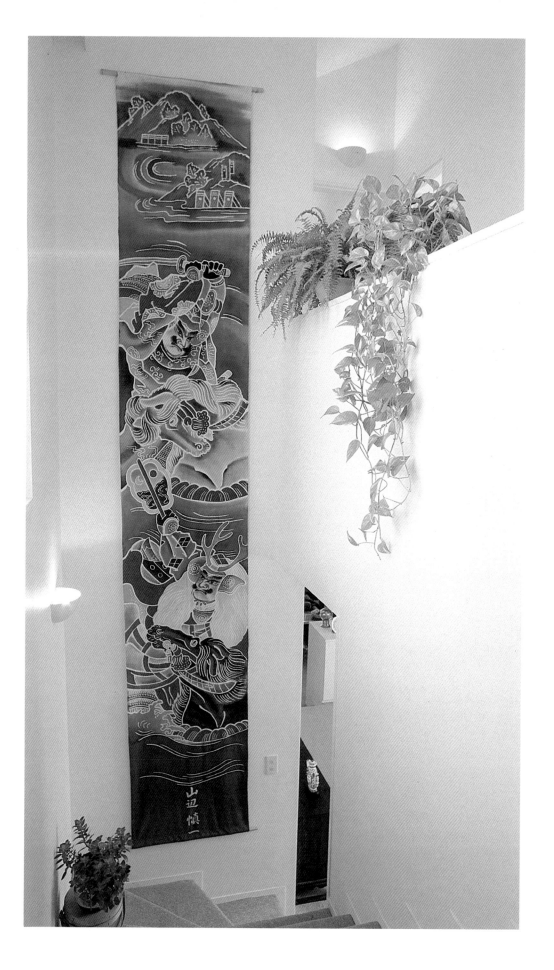

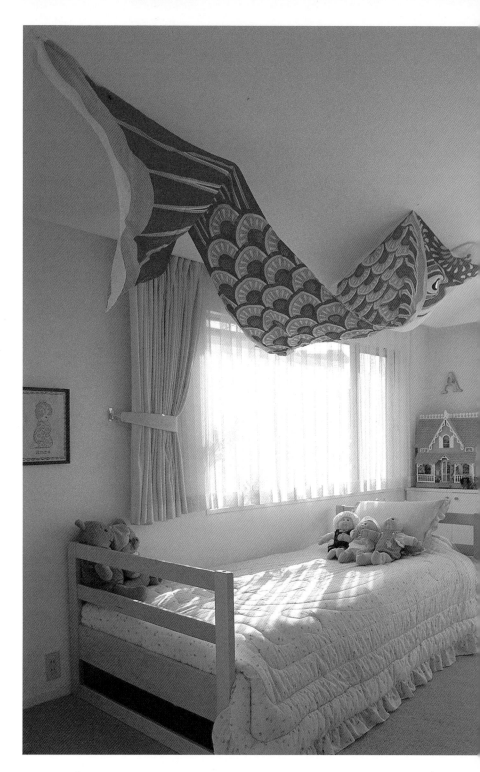

RIGHT: The ubiquitous carp becomes a canopy for the ubiquitous Cabbage Patch kids and their 10-year-old owner. The carp, suspended from a canted ceiling, is washable cotton, 15 feet long, and was acquired for a few hundred yen at the Heiwajima Fair.

OPPOSITE: In another instance of ingenuity, a newcomer to Tokyo was presented with the dilemma of finding a shower curtain for her Western proportioned shower. At an open market, she came across some nylon carp material not yet sewn into the fish shape. She simply stitched it to a shower curtain liner and it was done. It took a lot longer to find Western shower curtain hooks.

CARP

Giant carp, flying like airport windsocks, are a more common symbol of Children's Day than the long banners. Homeowners used to hoist one fish for each son, with the largest for the oldest son. Nowadays, nobody counts and "the more, the merrier," seems to prevail.

Why carp? The carp, considered the "king of river fish," is respected for its ability to swim upstream, so its determination to overcome obstacles is considered a fitting example for growing boys. The symbol is said to derive from an ancient Chinese legend about a carp that swam upstream and turned into a dragon.

The carp sold in neighborhood shops and department stores are commercially printed on nylon, cotton or paper. Handmade paper carp have all but disappeared, but occasionally hand-painted cotton carp turn up in small villages.

One Tokyo resident delights in keeping her father-in-law in Kansas well-stocked with carp windsocks. While Kansas has no shortage of scarecrows, it seems there is nothing better—or prettier—than Japanese carp for keeping grackle away from his swimming pool.

RIGHT: A paper carp, lightly stuffed, flies high over a little boy's bed. Like the nylon version, this kind is readily available in folkcraft stores. The masks are papier mâché reproductions from the city of Kurashiki.

BELOW: Foreign children are as eager as Japanese children to display flying carp (*koi-nobori*). One mother discovered a way to enjoy them all year long by stuffing them and turning them into pillows in her child's room.

Collections

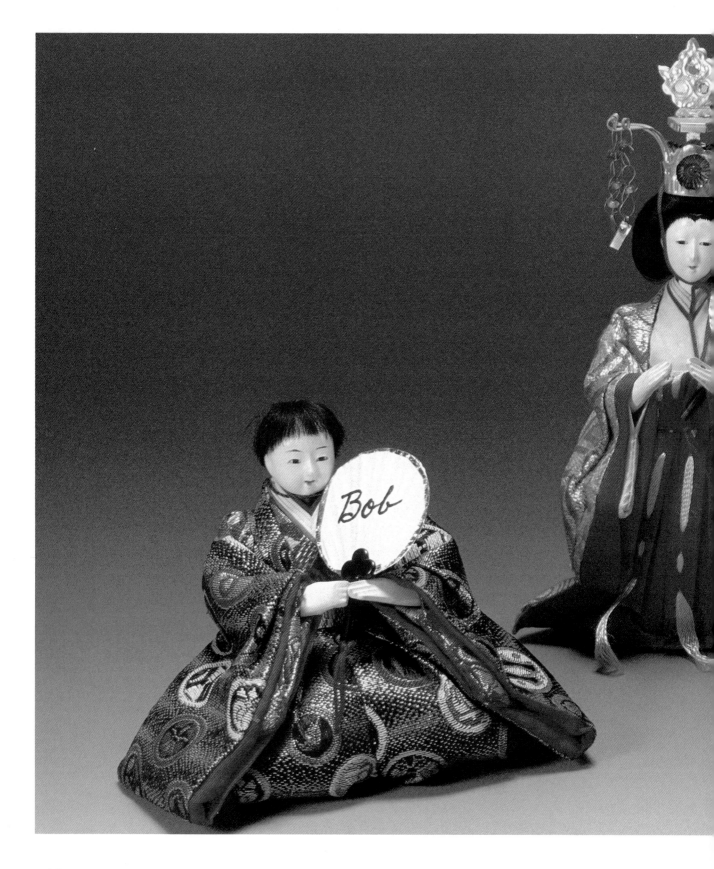

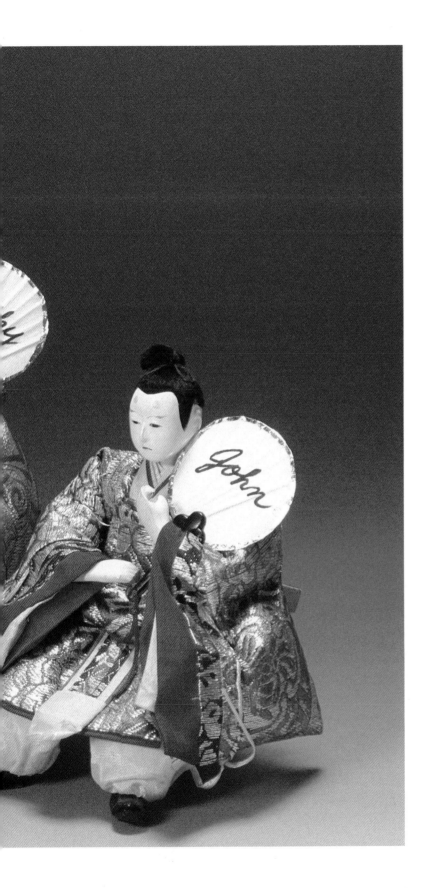

DOLLS

Once a year on Girls' Day, March 3, Japanese families take out their collection of *Hina* dolls for display on a tiered stand. Numbering 15 dolls in all, from an emperor and empress down to three servants, a complete set in richly brocaded robes is expensive by any standard. Sets are often built gradually or handed down, mother to daughter.

New dolls can be purchased readily, but single dolls or partial sets are often found second-hand at open markets. Because *Hina* dolls have always been for display rather than play, they survive in surprisingly good condition. Their pristine state is further insured by a superstition that if the dolls are on display too many days, the daughter will become an old maid.

Singly or in small groups, *Hina* dolls enhance many situations in Western homes. Certainly the prize for originality goes to Kathleen Nagro, who stations a doll at each place setting when entertaining. The hands that used to hold saké utensils now coyly hold place cards.

BROOMS

"The right tool for the right job" has long been a Japanese motto. John Lowe reports in *Japanese Crafts* that there are "special brushes and brooms for getting dust out of drawers, brushing false teeth, cleaning a radish grater, brushing iron kettles, garden brooms for sweeping moss, and a variety of brushes for different crafts . . . the old-fashioned interior is a forest of bamboo handles."

One Tokyo resident has grouped a broom collection in the kitchen around an antique American icebox. At left in Sara and Ken Hostelley's family room, some of Japan's specialized brooms take their place with those from other Asian countries. Duchess has cornered the best television seat under the appliquéd wall hanging from India.

SHOES

The recessed aprons of Japan's foyers are immediate reminders to shed shoes. However, one family realized that their *genkan* was the ideal place to display their collection of Asian footware. Four pair are shown above: Japan's traditional *geta* and *zori* plus straw snowshoes or *yuki-gutsu*. Styles and materials of snowshoes varied by region. Some were made from rice straw; others, from the more waterproof cattail rushes.

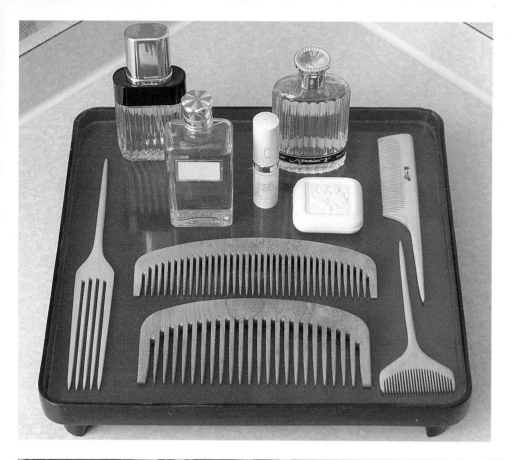

COMBS

A lacquer tray in a powder room frames handmade wooden combs. Combs used to be sacred to the Japanese, who believed that a person's soul lived in the teeth of the comb. Other legends consider a comb a charm against misfortune. The slender combs on the sides of the tray shown at left are part of a traditional marriage set of eight combs and two pins. Lighter color combs are made of boxwood, which is more expensive than camellia.

The wood must be thoroughly dried at least five years before combs are made. A

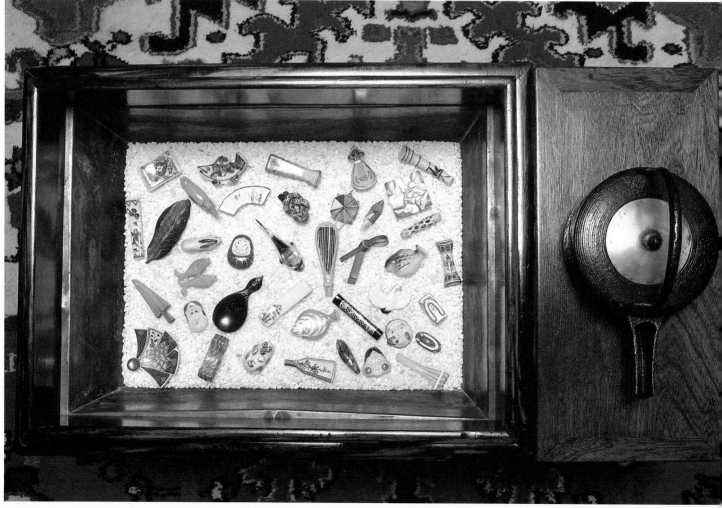

ally good comb, therefore, is ever washed. More than 200 different kinds of combs are still n the market, used principally or classic kimono hairstyles nd in the theater. The uperstition remains that it is ad luck to pick up a lost comb r give a comb as a gift.

CHOPSTICK RESTS

Chopstick rests (*hashi-oki*) have een part of Japanese ableware since the Heian eriod (794–1185). One of the arliest records of their use is an 11th century document showing silver crane-shaped rests, quite a bit larger than any shapes today. A mid-19th century article reports that on festive occasions, it was common to use ear-shaped holders.

Chopstick rests find an ideal display chest in a Tokyo style *hibachi* on the opposite page. Jane and Peter Haley's collection has been culled from many corners of Japan and Asia. Framed by their Oriental carpet, the chopstick rests seem to be trying to repeat its colorful pattern. The *hibachi* is made from zelkova (*keyaki*) with a black persimmon wood frame and has its original liner.

There are two important rules of etiquette to remember when using chopsticks themselves. Food is never to be passed from one person to another with chopsticks. And chopsticks should never stand vertically in the rice. This is done only when rice is offered to the dead at the family shrine. At picnics, a superstition emerges: disposable chopsticks are broken in half after use, so that the devil can't use them.

NETSUKE

Prized worldwide by collectors, *netsuke* are finely worked pieces of ivory, wood, tusks, horn, metal or porcelain that served as toggles for a man's purse or tobacco pouch. His pocketless kimono made a purse *de rigueur* and the toggle, like today's necktie, marked his individuality.

Although *netsuke* are convenient to collect, their miniature size and high value make them a bit difficult to display. With their collection in mind, George and Linda Hoza spotted the wooden case at left at an antique fair. It was holding a clock, but originally it may have been the shell of an outdoor shrine. George Hoza added shelves and lighting to create a shadow box and give these tiny sculptures the prominent position they deserve in their home.

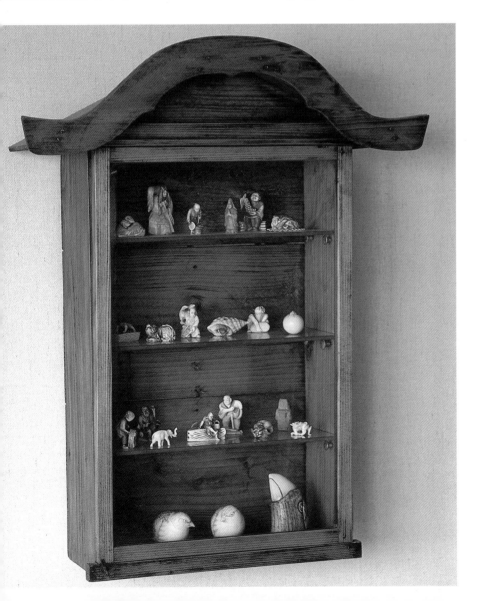

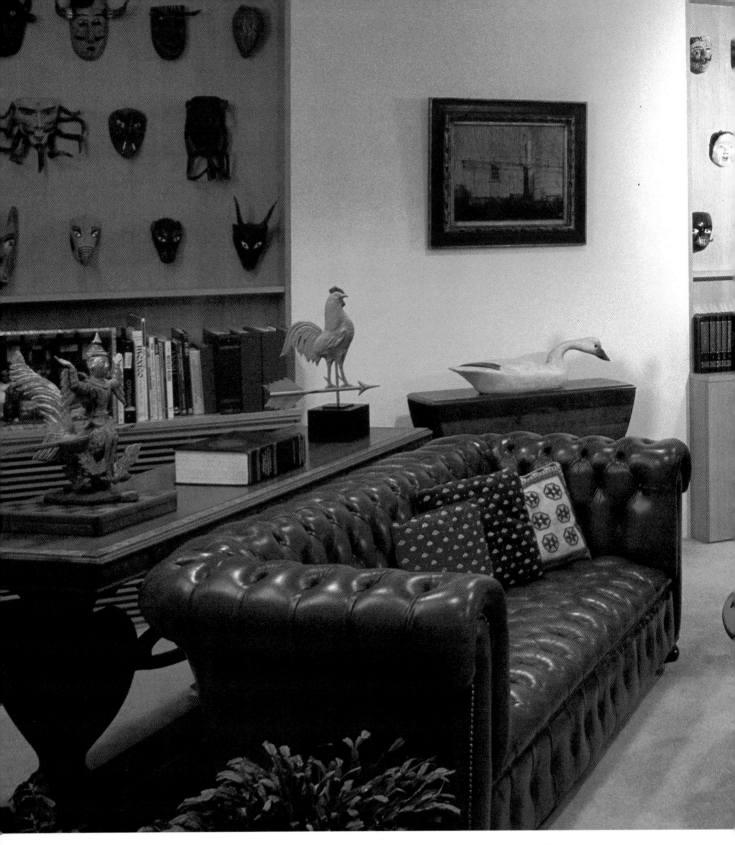

MASKS

Wherever there are curios, there are masks—grotesque, massive, sculptural, subtle or sublime. They represent centuries of tradition and derive from the work of master carvers.

Although antique masks are rare, a collector theoretically finds five broad categories to choose from: huge *Gigaku* masks for temple skits, emotional *Bugaku* masks for

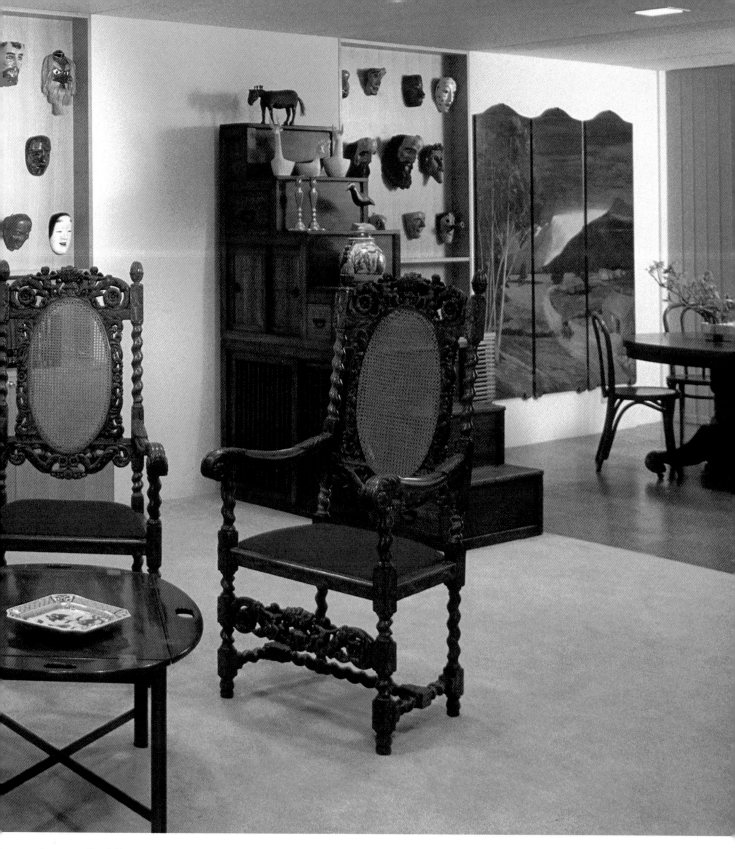

court dances, Buddhist *Gyōdō* masks for temple processions and the uniquely Japanese masks used for *Nō* and *Kyōgen* performances. Today's *Nō* mask carver uses the same techniques developed 500 years ago to fashion a personality that seems to come alive with slight movements of the actor's head.

Leslie and Larry Hillel's living room did not readily offer proper mounting space for their international collection of masks. Then Mrs. Hillel removed book shelves from three shallow recesses and turned them into perfect display alcoves.

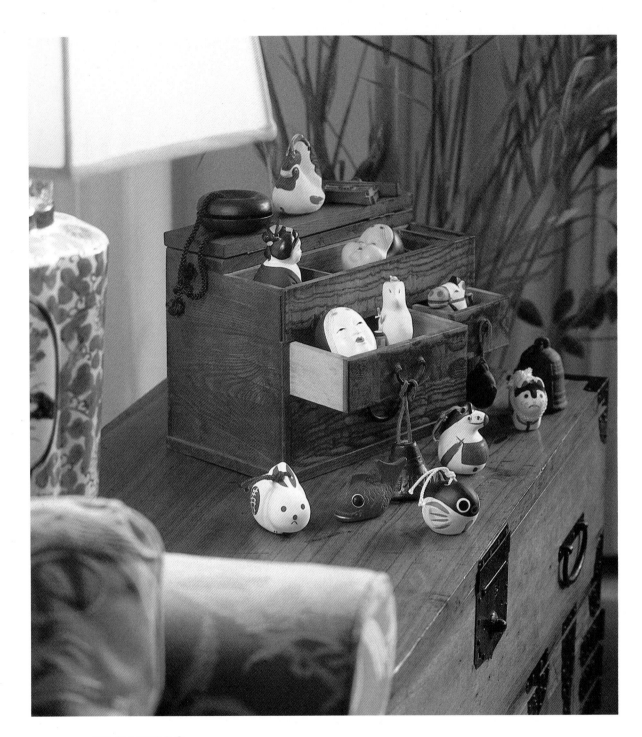

CLAY BELLS

Most large temples in Japan have giant bronze bells, which in the past called the faithful to prayer, announced the time, or summoned mendicant priests home from their begging trips through the city. According to one Buddhist sutra, the striking of the bell exorcizes evil.

Perhaps that is why souvenir clay bells are sold at temples today. The faithful buy them as talismans against evil and as a memento of their visit. But their whimsical shapes have an ecumenical appeal. Sheila Rosenthal's intriguing collection spills out of an antique sewing box in her living room.

FAMILY SHRINE

In addition to the Buddhist family altar, many homes also have miniature Shinto shrines, generally placed high on the wall on the *kami-dana* or God shelf. The shrine is often kept in the kitchen, although its location varies. Occasionally, it is decorated with *evergreen* sprays of *sakaki* to attract the gods.

Peggy and Brian Kiely's children delight in having a hand-crafted shrine in their front hall, since they enjoy outfitting it for the changing seasons. Their first impulse was to make it a haunted house, without knowing that an amusement park in Tokyo actually has a "Haunted Shrine." And without knowing that Japanese children often decorate their shrines with the same ghostly figures to pray for good weather for a school outing. Sometimes, the Kiely shrine is filled with Smurfs, sometimes Easter decorations. At Christmas, it becomes a Christian crêche, appropriately decorated again with sprays of evergreen.

BUTSUDAN

The *butsudan* or Buddhist family altar is one of the more massive pieces of Japanese furniture found in department stores and specialized shops. It represents the central portion of a temple's altar and is used for home devotion. The *butsudan's* many shelves are used to hold a variety of religious articles, including offerings of flowers and food and portraits of

deceased family members, who are venerated daily.

Since the *butsudan* remains a very important acquisition to the Japanese family, it is beautifully finished in various woods, including mulberry, cherry and sandalwood. The

chest's craftsmanship, size and versatile shelf arrangement suggest many uses to the Western eye. It is ideal, for example, as a stand up bar, but as Howell and Beverly Hammond have discovered with their *butsudan* shown on the previous page, it is best to keep the doors closed when entertaining Japanese guests. Their keyaki *butsudan* is over 100 years old with its lighting added by a private collector.

USU

At New Year's time, glutinous rice is pounded into a paste to form the special rice cakes (*mochi*) enjoyed throughout the holiday. Huge mallets do the job in sturdy wooden mortars, designed to take years of punishment. This unobstrusive planter, a 100-year-old rice mortar or *usu* in the home of Tae Young and Choong Suh Park, weighs about 250 pounds. It is taller than it appears at two and a half feet.

GETA

A wooden scuff or *geta* turns up on a bookshelf with playing pandas! *Geta* are known as much by their sounds as by their look. "Karan-koron" they say in Japan's onomatopoeic rich language. The flat, thonged slipper made of lightweight paulownia wood (*kiri*) was designed for muddy streets. Since the sole is supported by two thin slats, the actual surface in contact with the mud is reduced to a minimum. When

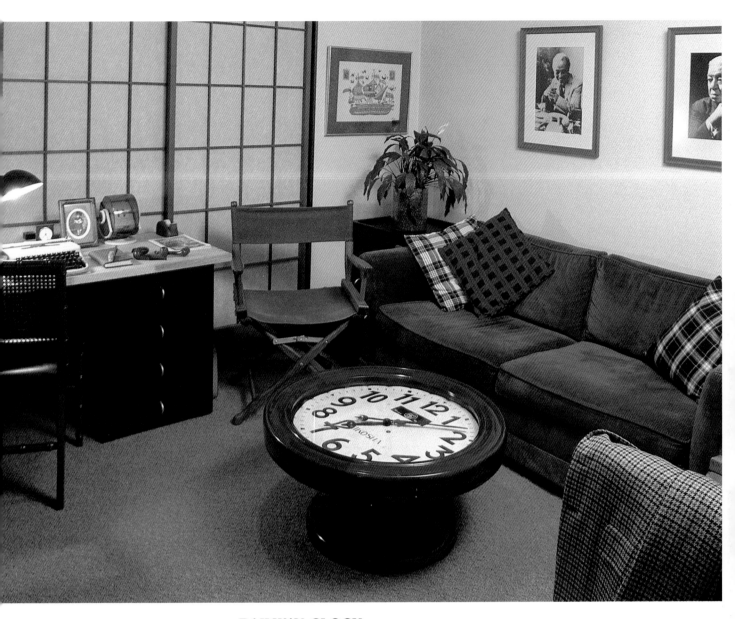

RAILWAY CLOCK

the 1950's brought Western dress and paved roads, the *geta*'s popularity declined. But they are still worn with *yukata* and a man's kimono and can be heard even today, clip clopping on a quiet night.

When an old Japanese railway station was being razed, Steve Parker spotted the waiting room clock among the memorabilia for sale. "Why not turn it into a coffee table?" he said to himself. To his astonishment, it still keeps perfect time in his studio, 30 years later.

BENKI

Perhaps the most puzzling pieces to be found at open markets are two items that used to be kept behind the scenes. These attractive pieces of blue and white ceramic are antique bathroom fixtures (*benki*) from Japanese inns, elaborate restaurants or wealthy homes. The standing shape from a man's lavatory has a flowery name in Japanese, *asagao*, which means "morning glory."

Since the standard Japanese bathroom fixture has always been unadorned, some suggest that these elaborately decorated pieces indicate European influence. Hand-painted ones are generally older than the stencilled designs. Most of the fixtures date from late Meiji (1868–1912) to early Showa (1926-present).

As a decorative item, they actually work best as planters or in the bathroom itself, with the floor model, perhaps holding magazines or wall-mounted around a faucet to form a sink.

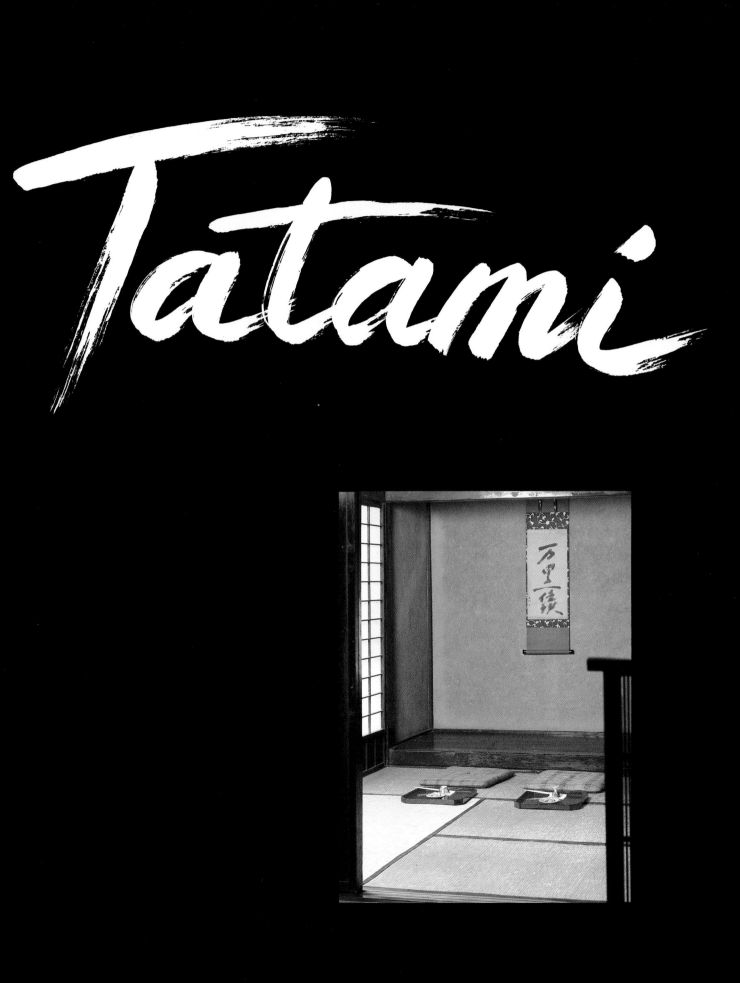

*Tatami is the soft creak and caress of a field of grass
at your feet and the sweet smell of straw in the morning.
It is like carpeting your living room with an early
autumn evening.*

John Herrick in *Discover Japan*

Various theories have been presented as to why Japan's floor-based culture never gave way to chairs. The reason may well lie simply with the tremendous appeal of living on straw. *Tatami*, the basic floor covering in the traditional interior and another hallmark of Japanese decor, originated as a sleeping pallet on a raised platform. It was moved about during the day for sitting. Gradually, more and more floor surface became covered until finally the entire floor was raised and "tatamied."

These mats are made of a core of rice straw, covered with soft reeds and bordered with a strip of fabric. The most important fact for a visitor to remember is that they are never walked on with shoes or even house slippers.

Tatami are surprisingly durable, lasting for years if they are aired out annually and cleaned regularly with a damp cloth or vacuumed with a special attachment. Their outer cover can be changed *every few years* by a professional to extend their lives. *Tatami* are roughly 3′ × 6′ and 2″ thick. Although variations are available, their standard dimensions provide a handy way to indicate the size of a room, as in "a six-mat room."

In the mid 1920's, it was fashionable for Japan's affluent society to have one Western room in their homes, furnished with imported rugs, upholstered chairs, bookcases and a piano. Now, like the encroaching *tatami* of the past, Western decor is taking over almost all of the interior of Japanese homes. And the situation is reversed. The Japanese now make an effort to have one *tatami* room for a quiet, subdued retreat. Its simple lines and uncluttered harmonies of natural materials offer an escape to a simpler lifestyle.

Westerners, too, have discovered these pockets of serenity and are imaginatively incorporating *tatami* rooms into their homes.

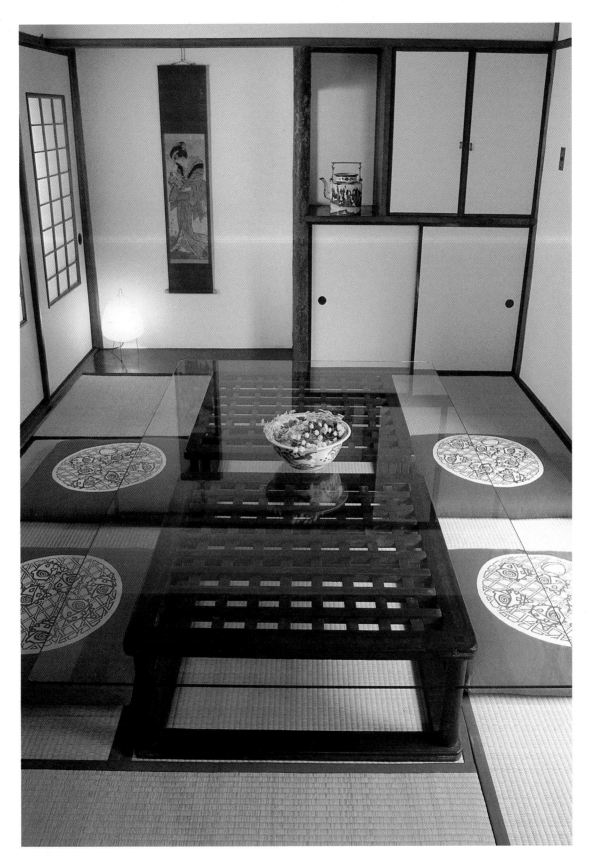

A *tatami* room is used as a dining room with two *kotatsu* supporting an oversized sheet of glass to accommodate as many as eight people.

OPPOSITE: A charming old home that has slowly evolved over a half century to become a Western dwelling provides a unique East-West blend. The open hearth fireplace in the living room sits at the edge of the raised *tatami* room that is shown on the previous page.

FOLLOWING PAGE: Although Suzette James is an architect by avocation only, she wasn't intimidated when her professional architect said it couldn't be done. Mrs. James wanted an authentic "open landscape" *tatami* room that could also be enjoyed from many different angles within her Western living room. The wooden panel near the ceiling to the left of her *tatami* triumph is a *ranma*.

PAGES 158–159: While not covered with *tatami*, this typically Japanese raised alcove sits at the end of Miki Hasegawa and Steve Parker's Western living room. Ms. Hasegawa collaborated on its design with the set designer of the *Kabuki* Theater, Hachiro Nakajima. Its success reflects the distinctly Japanese talent for not only maximizing space, but also for creating a theatrical illusion.

All the floor boards are removable for storing blankets in much the same way that food was stored in old farm houses. The well under the table (for Western legs) can also be planked over and the table replaced with a low one when floor seating is preferred. Both tables have hinged legs and can be stored below, along with a felt table top for games. Mr. Parker found the screen depicting the Genji-Heike War in an antique shop in several sections and had it re-mounted on a screen.

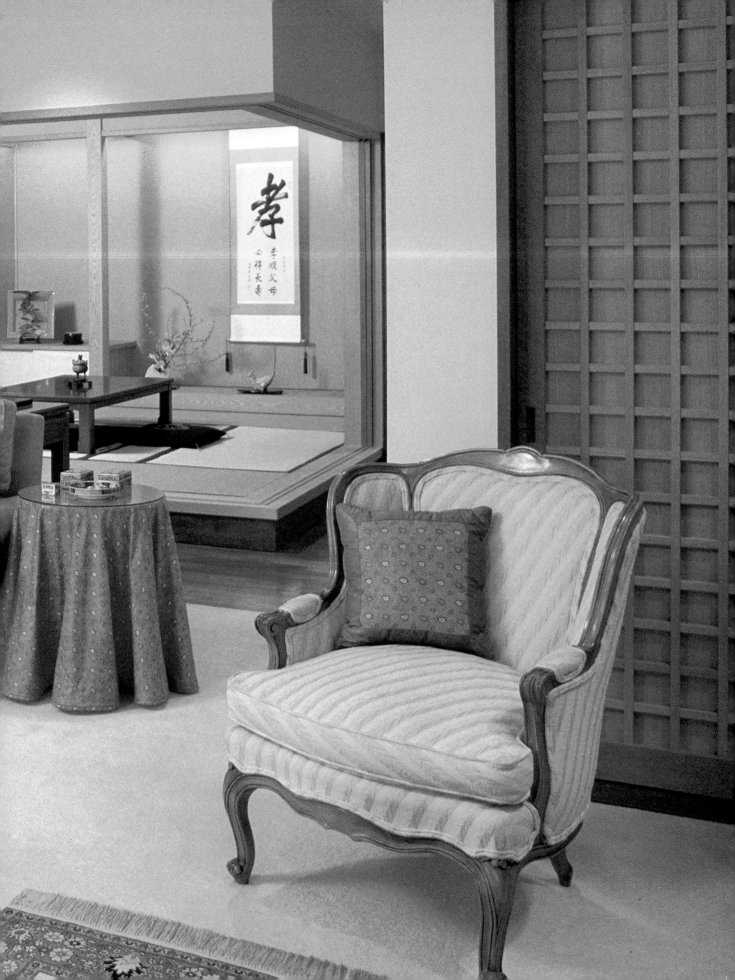

While many, *tatami* rooms in Tokyo residences are separate rooms off a corridor, Linda and George Hoza found an apartment with a *tatami* room that opened off the living room. When not in use, the entire room becomes a three-dimensional still life. Among its many treasures are an earthenware water jug, approximately 400 years old, and a 150-year-old *haiku* screen.

HISTORICAL PERIODS

Jōmon (Neolithic)
ca. 10,000–
ca. 200 B.C.

Yayoi
ca. 200 B.C.–
ca. 200 A.D.

Kofun (Tumulus)
200 A.D.–593

Asuka
593–710

Nara
710–794

Heian
794–1185

Kamakura
1185–1333

**Muromachi
(Ashikaga)**
1333–1573

Azuchi Momoyama
1573–1603

Edo (Tokugawa)
1603–1868

Meiji
1868–1912

Taisho
1912–1926

Showa
1926–1989

Heisei
1989–

ACCENTS SEEN IN BOOK

Folding screens made from kimono, obi or handmade paper (**pages 27, 127**): Maureen Duxbury, c/o Okura Oriental Art, 3-3-14 Azabudai, Minato-ku, Tokyo. Tel. 585–5309 or Antiques Tsurukame, 2-1-1 Shirogane, Minato-ku, Tokyo 108 Tel. 447–3990.

Pillows made from obi (**page 43**): Beverly Hills Pillow Company, a subsidiary of Elaine Barchan Interiors, 2261 Highland Oaks Drive, Arcadia, CA. 91006., U.S.A.

Handwoven **noren** and **placemats** by contemporary artists (**pages 114, 66**): Hirokuni Yahata, Tel. 584–2943, Tokyo.

Quilt made from antique stencil-dyed fabrics (**page 80**): Warabe Mingei, 71-1 Oginmachi, Takayama City, Gifu, 506 Japan. Tel. (0577) 32-3419.

Washi eggs (page 124): Carol Croll, Box 149C, Mazeppa, MN. 55956, U.S.A.

TOKYO MUSEUMS

Tokyo's many museums provide leisurely overviews of particular fields of antiques and folkcraft. A weekly schedule of all exhibitions at museums and department stores appears in the Saturday edition of The Japan Times. Descriptions of collections at 347 museums can be found in the book *Roberts' Guide to Japanese Museums of Art & Archeology* by Laurance P. Roberts. A few museums that have relevance to the items in this book are:

Crafts Gallery, National Museum of Modern Art,
3 Kitanomaru Koen, Chiyoda-ku. Tel. 211–7781.
Dyed textiles, porcelain, lacquerware, metalwork.

Japan Folk Crafts Museum (Nippon Mingeikan),
4-3-33 Komaba, Meguro-ku. Tel. 467–4527. Specializing in wood, pottery and straw. Special sale in November. Closed January and February.

Japan Traditional Craft Center, Plaza 246 Building, 2nd floor, 3-1-1 Minami Aoyama, Minato-ku. Tel. 403–2460.
10 to 6. Closed Thursdays. A non-profit center established by the Ministry of International Trade and Industry to publicize crafts and distribute information. Features: exhibitions, video tapes, English language library, kimono dressing class, lacquerware clinic, handicraft classes.

Kurita Museum, Nihombashi Hama-cho 2-17-9, Chuo-ku. Tel. 666–6246. 10 to 5 daily. Porcelain exhibition.

Matsuoka Museum of Art, 5-22-10 Shimbashi, Minato-ku. Tel 431–8284. Closed Mondays. Vast and diverse private collection.

Suntory Museum in Suntory Building, 1-2-3 Moto Akasaka, Minato-ku. Tel. 470–1073. 10 to 5. Closed Mondays. Changing exhibits of objects from Edo and Muromachi periods.

Yuasa Museum, International Christian University, 3-10-2 Osawa, Mitaka-shi, Tokyo 181. Tel. 0422-33-3340. Tue.-Fri. 10-5. Sat. 10-4:30. Closed national holidays and university vacations. Textiles, stencils, *mingei*, ceramics, *tansu*.

One of the best places in Japan to buy interesting antiques and folkcraft is a source that many visitors miss: Tokyo's department stores. All of the major stores have periodic exhibitions and sales, often with demonstrations by leading craftsmen. These are announced in the English language newspapers. Seibu's branch in Ikebukuro has a particularly rich program.

As for antique stores, a complete list is almost a book in itself. Patricia Salmon's paperback guide, *Japanese Antiques*, is an excellent starting point for the newcomer. Her book spells out locations, hours and merchandise of many shops in Tokyo, Kamakura and Kyoto.

The bi-monthly newspaper, The Tour Companion, available at hotel desks, carries an up-to-date guide to dealers in the Minato-ku section of Tokyo. Five reputable shops in Tokyo whose owners are extremely knowledgeable and who were helpful in the preparation of this book are:

Kikori Antique Gallery, 1–9–1, Hibarigaoka, Hoya-shi, Tokyo 202. Tel. 0424–21–7373. 10 to 6. Retail and wholesale.

Kurofune, 7–7–4 Roppongi, Minato-ku, Tokyo 106. Tel. 479–1552. 10 to 6. Closed Sundays, holidays.

Magatani Co. Ltd., 5–10–13 Toranomon, Minato-ku, Tokyo 105. Tel. 433–6321. 10 to 6. Closed Sundays and holidays.

Morita, 5–12–2 Minami Aoyama, Minato-ku, Tokyo 107. Tel. 407–4466. Weekdays 10 to 7, Sundays and holidays 12 to 6.

Nakamura Antiques, 2–24–9 Nishi-azabu, Minato-ku, Tokyo 106. Tel. 486–0636. 10:30–6:30. Closed Tuesdays. Retail and Wholesale.

Another paperback guide, *Kites, Crackers and Craftsmen* by Camy Condon and Kimiko Nagasawa, provides information about some of the Tokyo artisans whose small stores continue to provide everyday handicrafts. Important stores of general interest to the folkcraft collector are handmade paper shops and large stationery stores, plus:

Bingoya, 10–6 Wakamatsu-cho, Shinjuku-ku, Tokyo 162. Tel. 202–8778. 10 to 7. Closed Mondays.

Oriental Bazaar, 3–9–13 Jingumae, Shibuya-ku, Tokyo 150. Tel. 400–3933. 9:30 to 6:30. Closed Thursdays. Also carries antiques.

Prefecture Showrooms, Daimaru Department Store and Kokusai Kanko Building, next to Tokyo Station. Yaesu North Exit. Many regional handicrafts displayed by prefecture on the 8th and 9th floors of Daimaru and in approximately 30 showrooms in the adjacent Kokusai Kanko Building, floors 2, 3 & 4. Hours 10–5:30. Sat. 10–12:30. Kokusai Tel. 215–1181. Closed Sundays. Daimaru closed Wednesdays. Tel. 212–8011.

Washikobo, 1–8–10 Nishi-Azabu, Minato-ku, Tokyo 106. Tel. 405–1841. 10 to 6. Closed Sundays, holidays.

ANTIQUE MARKETS IN JAPAN

The following list of periodic antique markets in Japan represents open markets where vendors congregate, usually outdoors, to sell their wares. The merchandise falls into every category including genuine antiques, attic junk and intentional fakes.

The atmosphere is exhilarating with negotiation a must. The most determined shoppers arrive at opening time to compete with the antique store owners in search of the best buys.

TOKYO

Antique Market, 30 dealers
Hanae Mori Bldg., 3–6, Kita Aoyama, Minato-ku, Tokyo
3 minute walk from Omote-sando Station
(Subway Ginza Line)

Arai Yakushi Antique Fair, 80 dealers
Arai Yakushi Temple, First Sunday of each month
10 minute walk from Arai Yakushi Station (Seibu Line)

Boro-ichi Antique Market, 50 dealers
Boro-ichi Street, December 15–16 and January 15–16
5 min. walk from Setagaya Station
(Tokyu Setagaya Line)

Edo Shitamachi Tenjin Antique Market
Yushima Tenjin Shrine, Fourth Saturday of each month
5 min. walk from Yushima Station
(Subway Chiyoda Line)

Hanazono Shrine Antique Market, 80 dealers
Hanazono Shrine, Second and Third Sundays
5 minute walk from Shinjuku San-chome Station
(Subway Marunouchi Line)

Heiwajima Antique Market, 200 dealers
Heiwajima-Tokyo Ryutsu Center Bldg. at Ryutsu Center Station on Tokyo Monorail Line from JR-Hamamatsucho Station. Three consecutive days, four times a year in a modern exhibition hall (with restaurant facilities). For exact dates, call 950–0871. It is the most important single market in Japan.

Ikebukuro Antique Market, 30 dealers
Ikebukuro Sunshine Bldg., Third Saturdays and Sundays
10 minute walk from JR Ikebukuro Station

Kokubunji Antique Market, 10 dealers
Kokubunji Temple, Second Saturdays and Sundays
5 minute walk from JR Kokubunji Station (Chuo Line)

Nogizaka Antique Market, 50 dealers
Nogi Shrine, Second Sunday of each month
Nogizaka Station (Subway Chiyoda Line)

Roppongi Antique Fair, 30 dealers
Roppongi Roi Bldg., Fourth Thursdays and Fridays
3 minute walk from Roppongi Station
(Subway Hibiya Line)

Shinjuku Antique Market, 40 dealers
Dai-ichi Seimei Bldg., Third Fridays and Saturdays
10 minute walk from JR Shinjuku Station

Shofuda-kai Antique Market
Tokyo Bijutsu Club, Early July and Early December
(two days each, call 950–0871 for exact dates).
15 minute walk from Onarimon Station
(Subway Mita Line)

Togo No Mori Antique Market, 70–90 dealers
Togo Shrine, First and Fourth Sunday of each month
10 minute walk from JR Harajuku Station

Tokyo Antique Hall
2–9, Kanda Surugadai, Chiyoda-ku, Tokyo
5 minute walk from JR Ochanomizu Station

TOKYO SUBURBS

Kawagoe Antique Market, 50 dealers
Narita-fudo Temple, The 28th of each month
15 minute walk from Hon-Kawagoe Station
(Seibu Line)
Saiunji Temple, The 14th of each month
10 minute walk from Kawagoe Station (Seibu Line)

Kawasaki Antique Market, 30 dealers
Fujimi Baseball Ground, Around November 23rd
10 minute walk from JR Kawasaki Station

Sagami Antique Market, 10 dealers
Atsugi Shrine, First Saturday of each month
5 minute walk from Hon-atsugi Station (Odakyu Line)

Shonan Antique Market, 20 dealers
Yugyoji Temple, First Sunday of each month
20 minute walk from JR Fujisawa Station

Urawa Antique Market, 30 dealers
Sakuraso Street, The Last Saturday of each month
3 minute walk from JR Urawa Station

SHIZUOKA

Ogushi Shrine Antique Market, 30 dealers
Ogushi Shrine, Second Sunday of each month
3 minute walk from JR Shizuoka Station

NAGANO

Karuizawa Antique Market
Karuizawa Public Hall, August 1–31.
15 minute walk from JR Karuizawa Station

NAGOYA AREA

Henshoin Antique Market, 15 dealers
Henshoin Temple, Every 21st on Lunar Calendar
5 minute walk from Chiryu Station (Meitetsu Line)

Osu Kannon Antique Market, 30 dealers
Osu Kannon Temple, The 18th and 28th of each month
Near Osu Kannon-mae station (Subway Tsurumai Line)

KYOTO

Kobo Antique Market, 50 dealers
Toji Temple, First Sundays, The 21st of each month
5 minute walk from Toji Station (Kintetsu Line)

Tenjin Antique Market, 100 dealers
Kitano Tenmangu Shrine, The 25th of each month
30 minute by bus from JR Kyoto Station

OSAKA

Daishi Antique Market, 200 dealers
Osaka Shitennoji Temple, The 21st of each month
5 minute walk from Shitennoji-mae Station
(Subway Tanimachi Line)

Hatsu Tatsu Mairi Antique Market, 25 dealers
Sumiyoshi Taisha Shrine, Every Dragon Day
(approximately every two weeks)
5 minute walk from Torii-mae Station
(Nankai Hankai Line)

Koshindo Antique Market, 30 dealers
Koshindo Temple, Every Sunday
5 minute walk from Shitennoji-mae Station
(Subway Tanimachi Line)

Ohatsu Tenjin Antique Market, 12 dealers
Ohatsu Tenjin Shrine, First Friday of each month
5 minute walk from Umeda Station (Hanshin Line)

Sankaku Koen Antique Market
Sankaku Park, Every Sunday
5 min. walk from Dobutsuen-mae Station
(Subway Midosuji Line)

KOBE

Kobe Antique Market, 30 dealers
Sumadera Temple, First Sunday of each month
5 min. walk from Sumadera Station
(Sanyo Dentetsu Line)

HIROSHIMA AREA

Cancan Bazar (Kurashiki City), 30 dealers
Ivy Square, Consecutive national holidays
in May and Oct.
15 minute walk from JR Kurashiki Station

Koyasan Betsuin Antique Market (Fukuyama City)
Fukuyama Koyasan Betsuin Temple, First Sundays
3 minute walk from JR Fukuyama Station

Sumiyoshi Antique Market (Fukuyama City)
10 dealers
Sumiyoshi Square, Fourth Sunday of each month
15 minute walk from JR Fukuyama Station

SHIKOKU

Kochi City Antique Market, 10 dealers
Street near Kochi Castle, Every Sunday
10 minute walk from JR Kochi Station

These schedules are subject to change.

Sources of Japanese Goods and Design Services in the United States and Canada

This sampling of sources for things Japanese for the home and garden also includes museum gift shops, which are indicated by an asterisk. Note that some locations have E-mail addresses and Web sites.

ALABAMA

Oriental Imports
Old Crush Antique Mall
200 South McKenzie
Foley 36535
(334) 943-8154 or 2941
Fax 334-943-6672
Wide range of antiques,
including furniture, obi, textiles

ARIZONA

Orient East
6204 N. Scottsdale Road
Suite 104
(Lincoln Village Shops)
Scottsdale 85253
(602) 948-0489 / Fax 602-483-9364
Furnishings, artifacts, *shōji*,
teahouse construction

CALIFORNIA

Asakichi
Japan Center
1730 Geary Boulevard
San Francisco 94115
Main store #108
(415) 921-2147
Furniture, porcelain, tea ceremony utensils, cherry bark products, bamboo vases, lamps, candles, old Imari
Shop #206—Iron & bronze, including windchimes

***Asian Art Museum
of San Francisco**
Avery Brundage Collection
Golden Gate Park
San Francisco 94118-4598
Exhibition kiosk: (415) 379-8807

Roger Barber
114 Pine Street
San Anselmo 94960
(415) 457-6844
Antiques including *tansu*,
screens, porcelain, folkcraft

Elaine Barchan Interiors
2261 Highland Oaks Drive
Arcadia 91006
(818) 355-8674 / Fax 818-355-9340
By appointment
Antique textiles and obi
for Christmas tables

EN Japanese Arts and Crafts
2308 Hyperion Avenue
Los Angeles 90027
Tel & Fax (323) 660-0262
Tansu, kimono, toys, folk art.

Blue Horizons
205 Florida Street
San Francisco 94103
Tel & Fax (415) 626-1602
Shōji manufacturer specializing
in Western interior applications

Len Brackett
East Wind (Higashi Kaze), Inc.
21020 Shields Camp Road
Nevada City 95959
(916) 265-3744 / Fax 916-265-6994
Design and construction of custom-built
Japanese homes/rooms

Robert Brian Co.
Galleria/Design Center
101 Henry Adams, Space 136
San Francisco 94103
(415) 621-2273 / Fax 415-621-9827
Wide selection of antiques, *tansu* and
folkcraft. Principally wholesale

Bunka-Do
340 East First Street
Los Angeles 90012
(213) 625-1122 / Fax 213-625-8673
Paper, hanging scrolls, painted screens,
folkcraft, ceramics

Chadine Interior Design
15910 Ravine Road
Los Gatos 95030
(408) 354-0606 / Fax 408-354-4555
Interior designer and landscaper
specializing in Japanese aesthetics

Dandelion
55 Potrero
San Francisco 94103
(415) 436-9200 / Fax 415-436-9230
Garden lanterns, basins, iron wind bells,
river stones, woodblock prints, obi,
ikebana and *bonsai* accessories,
ceramics, glassware, iron teapots and
tea accessories
www.tampopo.com

Design Shoji
3000 King Ranch Road
Ukiah 95482
(707) 485-5550 / Fax 707-485-5559
Custom-made *shōji* panels available
through your designer or architect,
shipped nationwide

Elica's Paper
1801 Fourth Street
Berkeley 94710
(510) 845-9530
Washi—wide selection of Japanese
handmade paper

F. Suie One Company
1335 East Colorado Street
Pasadena 91106
Tel & Fax (213) 681-2221
Fine antiques and furniture—*tansu*,
ceramics, unusual accessories, screens,
scrolls, architectural pieces

Dodi Fromson Antiques
P.O. Box 49808
Los Angeles 90049
(310) 451-1110 / Fax 310-395-5737
By appointment
Wide range of decorative
antiques, especially textiles

Fumiki Fine Arts
2001 Union Street
San Francisco 94123
(415) 922-0573 / Fax 415-922-3316
Obi, porcelain, *tansu*, *netsuke*
hibachi, Imari, Japanese-inspired
works by local artists

The Gallery
27 Malaga Cove Plaza
Palos Verdes Estates 90274
(310) 375-2212
Antiques

Genji
Japan Center, Suite 190
22 Peace Plaza
San Francisco 94115
(415) 931-1616
Wide selection of chests,
folk art and kimono

Gump's
135 Post Street
San Francisco 94108
(415) 982-1616
800-766-7628
Wide collection of antiques, including
tansu, Imari, bronzes, dolls, screens
www.gumps.com

Hida Tools
1333 San Pablo Avenue
Berkeley 94702
(510) 524-3700
Professional tools for
Japanese architecture, *tansu*
hardware, Japanese plaster

Susanne Hollis Inc.
1008 Mission Street
South Pasadena 91030
(818) 441-0346 / Fax 818-441-5616
Tansu, lacquerware

Imari Inc.
40 Filbert Avenue
Sausalito 94965
(415) 332-0245
Specialists in screens and fine antiques

The Japan Trading Co.
370 Barneveld Avenue
San Francisco 94124
(415) 282-3818 / Fax 415-282-2644
Shoji, tatami, fusuma

Japanache
146 N. Robertson Boulevard
Los Angeles 90048
(310) 657-0155
Specializes in *tansu*. Also screens,
scrolls, accessories, fine art and
architectural pieces including doors

Japonesque
824 Montgomery Street
San Francisco 94133
(415) 391-8860 / Fax 415-391-3530
Wide selection of antique and
contemporary home furnishings

Kabuki Gifts & Imports
11355 Santa Monica Boulevard
Los Angeles 90025
(310) 447-2663
Folk art, gifts, some antiques,
old & new pottery, *washi*, art
supplies, papers, lanterns

Kasuri Dyeworks
1959 Shattuck Avenue
Berkeley 94704
(510) 841-4509 / Fax 510-841-4511
Kasuri, silk, *yukata* fabric by
the yard, wooden folkcrafts.
Mail order video available

Konishi Oriental Antiques
5820 Wilshire Boulevard
Los Angeles 90036
(213) 934-7131 / Fax 213-934-2953
Woodblock prints, scrolls, *netsuke*,
lacquerware, screens, porcelain, *tansu*

Kuromatsu
722 Bay Street
San Francisco 94109
(415) 474-4027
Antiques, folkcraft

* **Los Angeles County Museum of Art**
Japanese Pavilion
5905 Wilshire Boulevard
Los Angeles 90036
Shops: (213) 857-6520 or 857-6146
Books, art objects, ceramics,
paper products

Marukyo U.S.A.
Honda Plaza
448 East Second Street
Los Angeles 90012
(213) 628-4369
Kimono, obi, fabrics

McMullen's Japanese Antiques
3172 Bunsen Avenue
Ventura 93303
(805) 644-5234 / Fax 805-644-5574
Tansu, folk art, lacquerware, kimono,
porcelain, ceramics, obi, screens

* **Metropolitan Museum of Art Shop**
Century City Shop Center
1025 Santa Monica Boulevard, #102A
Los Angeles 90067
(310) 552-0905 / Fax 310-552-3614
&
South Coast Plaza
3333 Bristol Street
Costa Mesa 92626
(714) 435-9160 / Fax 714-435-9620
&
39 North Fairoaks Avenue
Pasadena, CA 91103
(818) 793-8618 / Fax 818-793-6748
Netsuke, lacquer boxes, prints, posters

Mikado (J. C. Trading, Inc.)
1737 Post Street
San Francisco 94115
(415) 922-9450
Kimono, dolls, porcelain, kitchenware

* **Mingei International Museum**
of World Folk Art
4405 La Jolla Village Drive, Bldg. 1-7
San Diego 92122
(619) 453-5300

Nakura Inc.
110 West Harris Avenue
S. San Francisco 94080
(415) 588-6115 / Fax 415-588-6560
E-mail: nakura@wco.com
Tansu, antiques, accessories

Narumi Japanese Antiques
and Dolls
1902 B Fillmore Street
San Francisco 94115
(415) 346-8629
Wide selection of 18th & 19th century
dolls, *tansu*, kimono, obi, Imari

Nichi Bei Bussan
1715 Buchanan Mall
San Francisco 94115
(415) 346-2117
&
140 Jackson Street
San Jose 95112
(408) 294-8048
Kimono, folk art, *noren*, *yukata* by the yard

Nobu
11357 Santa Monica Boulevard
Los Angeles 90025
(310) 477-3211 / Fax 310-478-1799
Vintage kimono and obi, baskets,
tansu and small furniture

Oriental Corner
280 Main Street
Los Altos 94022
(415) 941-3207 / Fax 415-941-3297
Wide range of antiques, *netsuke*,
lacquerware, porcelain, woodblock
prints, screens

Oriental Treasure Box
Olde Cracker Factory
Antique Shopping Center
448 W. Market Street
San Diego 92101
Tel & Fax (619) 233-3831
Tansu, kimono, obi, lacquerware,
folk art, porcelain, *hibachi*, dolls

Orientations
Showplace Square
195 DeHaro Street (15th St)
San Francisco 94103
(415) 255-8277 / Fax 415-552-5058
Wide range of porcelain, baskets,
tansu, screens, furniture, plus
garden lanterns, basins and
sculptures displayed in a "villa"

* **Pacific Asia Museum**
46 N. Los Robles Avenue
Pasadena 91101
(818) 449-2742

* **Phoebe Hearst Museum of**
Anthropology
University of California
Campus at Berkeley, Kroeber Hall
(510) 643-7648 or 642-3681

* **San Francisco Art Institute**
800 Chestnut
San Francisco 94131
(415) 749-4555
Japanese papers

Shibui Japanese Antiques
991 East Green Street
Pasadena 91106
Tel & Fax (818) 578-0908
E-mail: shibui@earthlink.net
Direct importer of a wide range of
antiques and folk art

Shige Nishiguchi Antique Kimono
Japan Center
1730 Geary Boulevard, #204
San Francisco 94115
(415) 346-5567
Vintage kimono, obi, kimono accessories,
yukata, antiques

Soko Hardware
1698 Post Street
San Francisco 94115
(415) 931-5510
Lanterns, carpenter's tools
(upstairs), porcelain, chopstick rests,
cookware (downstairs)

Soko Interiors
1672 Post Street
San Francisco 94115
(415) 922-4155
Garden accessories

Takahashi Oriental Decor
235 15th Street
San Francisco 94103
(415) 552-5511 / Fax 415-621-1741
Wide selection of antiques, furniture,
art and home furnishings, wood and bam-
boo interior construction material, rope and
dry hedge landscape materials, garden gates,
classic calligraphy, plus traditional paintings
and wooden carvings to order. Store covers
a city block

Takahashi Trading Corp.
200 Rhode Island Street
San Francisco 94103
(415) 431-8300 / Fax 415-621-1741
Home furnishings, wholesale only

Tampopo
55 Potrero
San Francisco 94103
(415) 436-9200 / Fax 415-436-9230
Traditional and contemporary arts and
crafts including cherrybark objects,
garden lanterns, woodblock prints,
ceramics, bronzeware, glassware,
ironware, *ikebana/bonsai* accessories.
Wholesale only (Catalog to trade)
www. tampopo.com

Tansu Collections
Greta Vriend Weaver
Box 1396
Menlo Park 94025
(415) 323-6272
By appointment
Haori, tansu, textiles, *mingei,*
customized lamps and furniture

Townhouse Living
1825 Post Street
San Francisco 94115
(415) 563-1417
Kimono, obi, folkcraft, furniture,
stone lanterns

M. Uota
163 Tomales Street
Sausalito 94965
Tel & Fax (415) 332-8419
Tatami craftsmen

Warren Imports
Far East Fine Arts
1910 South Coast Highway
Laguna Beach 92651
(714) 494-6505 / Fax 714-494-1067
Very large selection including *tansu,*
Imari, Satsuma, screens, obi, bronzes,
netsuke and garden lanterns

Yoko Japanese Art & Fabrics
1011 Mission Street
South Pasadena 91030
(818) 441-4758
Wide range of antiques and folk art

Yoshino Japanese Antiques
104 E. Colorado Boulevard
Pasadena 91105
(818) 356-0588 / Fax 818-356-0773
Tansu, porcelain, screens,
architectural items

The Zentner Collection
5757 Landregan Street
Emeryville 94608
(510) 653-5181 / Fax 510-653-0275
Very large selection of antiques,
especially *tansu* and *mingei*

COLORADO
Cherry Tree
P.O. Box 17815
Boulder 80308
Tel & Fax (303) 442-4814
Handcrafted furnishings, *andon,* lamps,
shōji, and home accessories. Wholesale,
retail mail order, custom furnishings.
Catalog available

*****Metropolitan Museum of Art Shop**
Cherry Creek Mall
3000 East First Avenue, #181
Denver 80206
(303) 320-8615 / Fax 303-320-8631
Netsuke, lacquer boxes, prints, posters

CONNECTICUT
*****Metropolitan Museum of Art Shop**
131 Westfarms Mall
Farmington 06032
(860) 561-5336 / Fax (860) 521-5469
&
Stamford Town Center
100 Grey Rock Place
Stamford 06901
(203) 978-0554 / Fax (203) 978-0042
Netsuke, lacquer boxes, prints, posters

Stephen Morrell
57 Cedar Lake Road
Chester, CT 06412
(860) 526-1558
Landscape designer specializing in
Japanese-style gardens

Red Lacquer
Susan Smith
285 North Avenue,
Westport 06880
(203) 454-1374 / Fax 203-222-9539
By appointment
Interior design, Asian style

Silk Road Gallery
131 Post Road East
Westport 06880
Tel & Fax (203) 221-9099
E-mail:silkroadgallery@msn.com
Hibachi, ranma, lacquerware, ceramics,
tansu, baskets, kimono, obi
lanterns, ironware, *kotatsu, haori*

Vallin Galleries
516 Danbury Road (Rte. 7)
Wilton 06897
(203) 762-7441 / Fax 203-761-9469
Fine porcelain, *tansu, hibachi,*
stone lanterns, art

DELAWARE
A Touch of the Orient
Garrett Snuff Mills
Yorklyn 19736
(302) 239-4636 / Fax 302-234-2257
Tansu, dolls, kimono, obi, designer fashions
crafted from antique Japanese fabrics

DISTRICT OF COLUMBIA
Arise Gallery
6925 Willow Street, N.W.
Washington, D.C. 20012
(202) 291-0770 / Fax 202-291-2073
Kimono, obi, *tansu, hibachi,* screens,
ranma, dolls, baskets, porcelain, prints

Asian Art Center
2709 Woodley Place, N.W.
Washington, D.C. 20008
(202) 234-3333
Porcelain, lacquerware,
watercolor screens & scrolls

*****Freer Gallery of Art**
Arthur M. Sackler Gallery
Smithsonian Institution
Jefferson Drive at 12th Street, S.W.
Washington, D.C. 20560
(202) 357-1300 museum
(202) 357-4880 museum shop

Ginza "Things Japanese"
1721 Connecticut Avenue, N.W.
Washington, D.C. 20009
(202) 331-7991 / Fax 202-265-1319
Folk art and crafts, pottery, kimono, futons,
shōji, stone lanterns, basins, books, sta-
tionery, *ikebana/bonsai* art supplies

*****The Textile Museum**
2320 S Street, N.W.
Washington, D.C. 20008
(202) 667-0441

FLORIDA
Carol Croll/Incredible Eggs
4238 45th Street S.
St. Petersburg 33711
Washi eggs, kimono, *washi* jewelry
(813) 867-4180

Galleries at Northgate
1839 Northgate Boulevard
Sarasota 34234
Tel & Fax (941) 358-0814
Wide range of antiques

*Morikami Museum and
Japanese Gardens
4000 Morikami Park Road
Delray Beach 33446
(561) 495-0233
Gardens open daily. Museum and
shop closed Mondays

Vilda B. de Porro
211 Worth Avenue
Palm Beach 33480
(561) 655-3147 / Fax 561-833-9549
Wide range of antiques including *hibachi*,
cloisonné, porcelain, *inro*, ivory, *netsuke*

GEORGIA
Ichiyo Art Center
A Division of the Ichiyo
School of *Ikebana*
432 East Paces Ferry Road
Atlanta 30305
(404) 233-1846 / Fax 404-233-8012
800-535-2263
E-mail: Ichiyoart@ad.com
Wide selection of *ikebana* containers & sup-
plies. Customized *ikebana* for events.
Japanese papers, prints, paintings, sumi-e
& calligraphy supplies, home accessories.
Exhibitions, classes. Catalogs available.

**J.H. Elliott Appraisal and
Antique Company**
537 Peachtree Street, N.E.
Atlanta 30308
(404) 872-8233
Antiques

*Metropolitan Museum of Art Shop**
Lenox Square
3393 Peachtree Road NE
Atlanta 30326
(404) 264-1424 / Fax 404-264-1370
Netsuke, lacquer boxes, prints, posters

**Sahara Japanese Architectural
Woodworks, Inc.**
1716 Defoor Place N.W.
Atlanta 30318
(404) 355-1976
Home construction, *shōji* screens,
teahouses, wood craft

Shiki Handcrafted Japan
Perimeter Mall, Suite 2130
4400 Ashford Dunwoody Road
Atlanta 30346
Toll free: 888-Toshiki
(770) 399-7777 / Fax 770-399-7766
E-mail: blues@shiki-japan.com
Traditional, handcrafted ceramic
tableware and furnishings, *noren*,
fabric, accessories, *mingei*
www.shiki-japan.com

HAWAII
Robyn Buntin of Honolulu
848 S. Beretania Street
Honolulu 96813
(808) 523-5913 / Fax: 808-536-6305
E-mail: rbuntin@lava.net
Antique & contemporary art, including
woodblock prints, sculptures, Buddhist
images. Also obi and framed antique
fabrics. *Netsuke* specialists.
www.robynbuntin.com

Bushido Antiques
1684 Kalakaua Ave, Suite A
Honolulu 96826
(808) 941-7239 / Fax 808-943-0214
Ceramics, kimono, obi, swords

Garakuta-Do
580 North Nimitz Highway
Honolulu 96817
(808) 524-7755 / Fax 808-524-7752
Tansu, Imari, *mingei*, textiles

*Honolulu Academy of Arts**
900 South Beretania Street
Honolulu 96814
(808) 532-8703 / Fax 808-532-8787

Amaury Saint-Gilles
P.O. Box E
Papa'aloa, Hawaii 96780
Tel & Fax (808) 962-6884
or 808-776-1800
By appointment only
Contemporary fine art, graphics
and ceramics

ILLINOIS
Aiko's Art Materials
3347 N-Clark Street
Chicago 60657
(773) 404-5600 / Fax 773-404-5919
Washi, contemporary prints

Decoro
224 East Ontario Street
Tel & Fax (312) 943-4847
&
2000 West Carroll Street
(312) 850-9260 / Fax (312) 850 9261
Chicago 60611
Tansu, kimono, antique furniture,
decorative objects

Saito Oriental Antiques, Inc.
Suite 428
645 North Michigan Avenue
Chicago 60611
(312) 642-4366
Appointment suggested
Porcelain, bronzes, sculpture,
lacquerware, woodblock prints,
antique paintings

J. Toguri Mercantile Co.
851 West Belmont Avenue
Chicago 60657
(773) 929-3500 / Fax 773-929-0779
Lacquerware, kimono, futons,
lanterns, screens

KENTUCKY
Boones Antiques
4996 Old Versailles Road
Lexington 40510
Tel & Fax (606) 254-5335
Porcelain, furniture
8:30-5:30 Mon-Sat

*Headley-Whitney Museum**
4435 Old Franklin Pike
Lexington 40510
(606) 255-6653
Porcelain, decorative art

Wakefield-Scearce Gallery
525 Washington Street
Shelbyville 40065
(502) 633-4382 / Fax 502-633-5608
Porcelain, some furniture

LOUISIANA
*New Orleans Museum of Art**
1 Collins Diboll Circle, City Park
New Orleans 70174
(504) 488-2631 x680
Large collection of Asian art

**Oriental Art and Antiques of
Diane Genre**
New Orleans 70130
(504) 595-8945 / Fax 504-525-7281
By appointment: *netsuke*, teapots,
selected objets d'art

MAINE
Ross Levett Antiques
Tenants Harbor 04860
(207) 372-8407
Antiques

Sign of the Owl
Coastal Route 1
Northport
Mailing address: 243 Atlantic Highway,
Northport 04849
(207) 338-4669
Changing collection including *netsuke*,
inro, vases, porcelain, Kutani, Satsuma

MARYLAND
Knight-Flight
P.O. Box 1971
Frederick 21702-0971
(301) 695-2890
Porcelain, pottery, furniture, textiles,
silver, bronzes, woodblock prints, interior
decoration, estate sales & appraisals

Travis Price, Architects, Inc.
7050 Carroll Avenue
Takoma Park 20912
(301) 270-9222 / Fax 301-270-4209
Architecture, interiors and furniture in a
pure Japanese, modern or mixed idiom.
Specializing in solar and environmental
design, nationally and internationally

Shogun Gallery
P.O. Box 5300
Gaithersburg 20882
(800) 926-4255 / Fax 301-948-0899
Three centuries of woodblock prints, sword
guards, dolls, *netsuke*
www.shogungallery.com

MASSACHUSETTS
Alberts-Langdon, Inc.
126 Charles Street
Boston 02114
(617) 523-5954 / Fax 617-523-7160
Furniture, paintings, porcelain

Asian Antiques
199 Stockbridge Road (Rte. 7)
Great Barrington
(413) 528-5091
Asian furniture, sculpture and
art for home, garden and temple.
Retail and wholesale.

Burt Associates Bamboo
P.O. Box 719-N
Westford 01886
(508) 692-3240
E-mail: bamboo@bamboos.com
Bamboo plants and handicrafts

* **Children's Museum**
300 Congress Street
Boston 02210
(617) 426-6500

Judith Dowling Asian Art
133 Charles Street
Boston 02114
(617) 523-5211 / Fax 617-523-5227
E-mail: shinto10@aol.com
Wide range of fine art, folk art, scrolls,
screens, woodblock prints, Buddhist art.
Exhibitions. Sotheby Internet associate.

Eastern Accent
237 Newbury Street
Boston 02116
(617) 266-9707 / Fax 617-536-5810
Contemporary, handcrafted
designs for dining and the home

Robert C. Eldred Co., Inc.
1483 Route 6A
East Dennis 02641
(508) 385-3116 / Fax 508-385-7201
E-mail: eldreds@capecod.net
Wide selection of antiques,
arts and accessories
www.capecod.net/eldreds

* **Isabella Stewart Gardner Museum**
280 The Fenway
Boston 02115
(617) 566-1401

* **Museum of Fine Arts, Boston**
465 Huntington Avenue
Boston 02115
(617) 267-9300

George Walter Vincent
Smith Art Museum
222 State Street
Springfield 01103
(413) 263-6890

* **Peabody Essex Museum**
East India Square
Salem 01970
(508) 745-1876 / Fax 508-744-6776
Folkcraft

Zen Associates, Inc.
124 Boston Post Road
Sudbury 01776
(508) 443-6222 / Fax 508-443-0368
Landscape architecture
(interior, exterior), estate design
www.zenassociates.com

MICHIGAN
D and J Bittker Gallery Ltd.
26111 W 14 Mile Road
Franklin 48025
(810) 932-2600
Antiques

The Lotus Gallery
1570 Covington Drive
Ann Arbor 48104
(313) 665-6322
Antiques, including *netsuke*,
woodblock prints, ceramics

MINNESOTA
Sharen Chappell
P.O. Box 9091
North St. Paul 55109
(612) 777-8910
Netsuke, lacquerware

MISSISSIPPI
East West Antiques
400 Cherokee Drive
McComb 39648
(601) 684-4638 / Fax 601-684-8565
www.eastwestantiques.com
Large selection of antique silk obi

MISSOURI
Asiatica Ltd.
4824 Rainbow Boulevard
Westwood, Kansas 66205
(913) 831-0831 / Fax 913-831-1110
Furniture, textiles, kimono, obi, *mingei*

Brookside Antiques
6219 Oak Street
Kansas City 64113
(816) 444-4774 / Fax 816-361-8088
Furniture, woodblock prints,
porcelain, cloisonné

* **Nelson-Atkins Museum of Art**
4525 Oak Street
Kansas City 64111
(816) 561-4000

MONTANA
Cherry Tree Design, Inc.
34154 E. Frontage Road
Bozeman 59715
(800) 634-3268
(406) 582-8800 / Fax 406-582-8444
Custom *shōji*, freestanding screens,
tatami mats, light fixtures. Wholesale only.
Catalog available.

NEW HAMPSHIRE
Joanne Wise
The Wise Collection
P.O. Box 286, Pout Pond Lane
Lyme 63768-0286
(603) 795-2889 / Fax 603-795-2890
Contemporary paintings, prints,
pottery and sculpture

NEW JERSEY
Ivory Bird
555 Bloomfield Avenue
Montclair 07000
(201) 744-5225 / Fax 201-744-3674
Imari, embroidery, prints
Netsuke, laquer boxes, prints, pottery
and sculpture

* **Metropolitan Museum of Art Shop**
Mall at Short Hills, Short Hills 07078
(201) 376-4466 / Fax 201-376-8731

NEW MEXICO
Five Eggs
Everything Japanese
213 West San Francisco Street
Santa Fe 87501
(505) 986-3403
Antiques, traditional futons, kimono, ceram-
ics, *mingei*, *yukata*, *tatami*

Mary Hunt Kahlenberg
1571 Canyon Road
Santa Fe 87501
(505) 983-9780 by appointment
Fax 505-989-7770
Textile arts

NEW YORK
A/N/W Crestwood
315 Hudson Street
New York City 10013
(212) 989-2700
800-525-3196
Fax: 212-929-7532
Largest importer of Oriental
papers in U.S. Call for retail sources
in 50 states, Canada and abroad

Asia Society
725 Park Avenue
New York City 10021
(212) 288-6400
Keyaki stationery boxes, ironware
teapots, ceremonial teacups—
Shino-ware

Azuma Gallery
50 Walker Street
New York City 10013
(212) 925-1381 / Fax 212-966-6491
Changing exhibition and sale of
woodblock prints, ceramics, kimono,
sculpture, swords, bronze, lacquerware

Bonsai Studio
1243 Melville Road
Farmingdale 11735
(516) 293-9426
Classic trees, containers, lessons, tours

*__Brooklyn Museum__
200 Eastern Parkway
Brooklyn 11238 / (718) 638-5000

E. & J. Frankel Ltd.
1040 Madison Avenue (79th St.)
New York City 10021
(212) 879-5733 / Fax 212-879-1998
Antique paintings, *netsuke*,
porcelain, textiles

Dai Ichi Arts, Ltd.
24 West 57th Street
New York City 10019
(212) 262-0239 / Fax 212-262-2330
Fine contemporary ceramics
www.daiichiarts.com

David H. Engel
Landgarden
215 Park Avenue South
New York 10003
(212) 228-9500 / Fax 212-673-3288
Landscape architects

Felissimo
10 West 56th Street
New York City 10019
(212) 247-5656 / Fax 212-956-3955
Innovative designs by environmentally aware
artisans—gifts, tableware and
handcrafted home furnishings—
displayed in a 100-year-old brownstone

Flying Cranes Antiques Ltd.
Manhattan Art & Antiques Center
1050 Second Avenue (55th St.)
Galleries 55 and 56
New York City 10022
(212) 223-4600 / Fax 212-223-4601
Edo and Meiji period antiques:
Satsuma, Imari, Makuzu Kozan porcelains,
Hirado-ware, bronze & multi-metalwork,
cloisonné, silver, samurai swords, fittings &
related weaponry

Gordon Foster Antiques
1322 Third Avenue (75th Street)
New York City 10021
(212) 744-4922 / Fax 212-727-1703
Mingei, baskets, *tansu*,
ceramics, porcelain

Susan Geffen
Sandstrom-Geffen Enterprise
17 Bayberry Road
Armonk 10504
(914) 273-3015 / Fax 914-273-3014
By appointment
Interior design with a Japanese accent

Grillion Corporation
189-193 First Street
Brooklyn 11215
(718) 875-8545
Shōji

Hayama
19 Main Street
Southampton 11968
(516) 287-4182
Porcelain, *tansu*, screens, *mingei*, lacquer

Imperial Fine Oriental Arts
790 Madison (66th Street)
New York City 10021
(212) 717-5383 / Fax 212-249-0333
Antique ceramics & works of art

Japanese Screen
23-37 91st Street
East Elmhurst 11369
(718) 803-2267 / Fax 718-478-8864
By appointment only
Shōji, *tatami*, *fusuma*, lamps

Kate's Paperie
8 West 13th Street
New York City 10011
(212) 633-0570
&
561 Broadway
New York City 10012
(212) 941-9816
Wide selection of *washi*

Kaikodo
164 East 64th Street
New York City 10021
(212) 223-0121 / Fax 212-223-0124
Paintings and screens

Kimono House
93 E. 7th Street
New York City 10012
(212) 508-0232
Antique kimono, obi,
geta, *zōri*, ceramics

Leighton R. Longhi
P.O. Box 6704
New York City 10128
(212) 722-5745 / Fax (212) 996-0721
Museum quality fine art

Miya Shoji & Interiors, Inc.
109 West 17th Street
New York City 10011
(212) 243-6774 / Fax 212-243-6780
Japanese rooms, *shōji*, *fusuma*,
light fixtures, stone lanterns,
tatami platforms, *tatami* rooms,
tansu construction

*__Metropolitan Museum of Art__
1000 Fifth Avenue
New York City 10028
(212) 879-5500
Gift shop: *netsuke*, lacquerware,
ceramics, posters
&
Satellite Shops:
Rockefeller Plaza
15 W. 49th Street
New York City 10020
(212) 332-1360 / Fax 212-332-1390
&
Macy's
151 West 34th Street
New York City 10001
(212) 268-7266 / Fax 212-643-9438
&
SoHo
113 Prince Street
New York City 10012
(212) 614-3000 / Fax 212-614-3293
&
The Cloisters
Fort Tryon Park
New York City 10040
(212) 923-3700 / Fax 212-795-3640
&
The Americana Shopping Center
2106 Northern Boulevard
Manhasset 11030
(516) 627-7474 / Fax 516-627-7568
Netsuke, lacquer boxes, prints, posters

Miyamoto Japanese Antiques
25 Madison Street
Sag Harbor 11963
(516) 725-1533
In Manhattan by appointment:
(212) 532-2192
Wide variety of furnishings
and textiles

Naga Antiques Ltd.
145 East 61st Street
New York City 10021
(212) 593-2788 / Fax (212) 308-2451
Fine collection of antique Japanese screens,
lacquerware, sculpture,
ceramics and objets d'art displayed
in a garden brownstone.

Old Japan, Inc.
382 Bleecker Street
New York City 10014
(212) 633-0922
www.oldjapaninc.com
E-mail: amie@oldjapaninc.com
Wide range of antiques and gifts, including
tansu and *mingei*, silk kimonos and kimono
fabric, *yukata*, *washi* eggs, dolls

Orientations Gallery
802 Madison Avenue
New York City 10021
(212) 772-7705 / Fax 212-772-9661
19th-century decorative art,
cloisonné, Satsuma, metalwork, inlaid
bronzes, ivory, wood carvings, silver,
netsuke, art lacquer, *inro*, *ojime*

John Rogers
Southampton 11968
(516) 283-7209 / Fax 516-283-5952
Interior design in the Asian spirit

Ronin Gallery
605 Madison Avenue (58th Street)
New York City 10022
(212) 688-0188 / Fax 212-593-9808
Woodblock prints (17th through 20th century), *netsuke*, pottery, sword guards

Sara
952 Lexington Avenue (70th Street)
New York City 10021
Tel & Fax (212) 772-3243
E-mail: cumix@earthlink.net
Contemporary pottery

Takashimaya
693 Fifth Avenue
New York City 10022
(212) 350-0100 / Fax 212-350-0542
Screens, *tansu*, baskets,
lacquerware, porcelain

Talas
568 Broadway, Suite 107
New York City 10012
(212) 219-0770 / Fax 212-219-0735
Handmade Japanese paper

Tansuya Corporation
159 Mercer Street
New York City 10001
(212) 966-1782 / Fax 212-925-0342
Furniture, screens, lacquerware,
contemporary art

Things Japanese
127 E. 60th Street
New York City 10022
(212) 371-4661 / Fax 212-371-1162
Woodblock prints, *mingei*, kimono, textile
baskets, Imari, small furniture, *netsuke*,
dolls, ceramics, lacquerware

NORTH CAROLINA
Kotani Oriental Antiques
324 East Lane Street
Raleigh 27601
(919) 856-0508 / Fax 919-839-1018
Art and antiques, including Imari,
furniture, kimono and obi

Stone Lantern Inc.
309 Main Street
Highlands 28741
(704) 526-2769 / Fax 704-526-4751
Furniture, porcelain, screens,
garden accessories

OHIO
Mary Baskett Gallery
1002 St. Gregory Street
Cincinnati 45202
(513) 421-0460
Ceramics, Oriental art

*Cleveland Museum of Art
1150 East Boulevard
Cleveland 44106
(216) 421-0931 / Fax 216-421-0424
Books, posters, notecards, postcards

*Metropolitan Museum of Art Shop
352 Columbus City Center Drive
Columbus 43215
(614) 221-7886 / Fax 614-221-8054
Netsuke, lacquer boxes, posters, prints

Mitzie Verne Collection
2207 Murray Hill Road
Cleveland 44106
(216) 231-8866 / Fax 216-231-8877
Contemporary & antique prints,
hand stencil dyed prints, screens,
scrolls, contemporary ceramics. Also
prints & paintings by American artists who
have lived or studied in Japan

OREGON
Shibumi Trading Ltd.
148 North 14th Street
Springfield 97477
Mailing address:
P.O. Box 1-F
Eugene 97440
(888) 744-1832 / Fax 541-744-1834
Stone & iron lanterns, basins & guideposts,
bamboo deer scarers, ceramic planters.
Mail order catalog available

Shogun's Gallery
206 Northwest 23rd Avenue
Portland 97210
(503) 224-0328 / Fax 503-292-4254
E-mail: okadaking@aol.com
Tansu, woodblock prints, Imari, bronzes,
textiles, baskets

PENNSYLVANIA
Japan Artisans
15 West Ferry Street
New Hope 18938
(215) 862-2429
Handmade papers & art supplies,
pottery, tea bowls, handmade *ikebana*
containers, *kenzan*

Liao Oriental Antiques
609 Bainbridge Street
Philadelphia 19147
(215) 925-1809 / Fax 215-574-9410
Tansu, especially large ones,
lacquer, textiles, obi, *mingei*

George Nakashima, Woodworker, S.A.
293 Aquetong Road
New Hope 18938
(215) 862-2272 / Fax 215-862-2103
E-mail: gnakashima@msn.com
Custom-designed, handcrafted
furniture made from select hardwoods

Oriental Gallery
6444-1 Route 202
New Hope 18938
(215) 862-0366
Ceramics, *tansu*, *hibachi*, *netsuke*, bronzes
Pearl of the East
1615 Walnut Street
Philadelphia 19100
(215) 563-1563 / Fax 215-563-3775
&
644 Lancaster Avenue
Berwyn 19312
(610) 644-4355
Furnishings, porcelain, futons

Three Cranes Gallery
82 South Main Street
New Hope 18938
(215) 862-5626
Tansu, porcelain, textiles, prints,
shōji, *tatami*, scrolls, screens,
contemporary art

RHODE ISLAND
Nortons' Oriental Gallery
415 Thames Street
Newport 02840
Mailing address: P.O. Box 65
Newport 02840
(401) 849-4468 / Fax 401-846-0749
Antiques, art, specialists
in framing Oriental textiles

Oriental Arts Ltd.
Brickmarket Place
Newport 02840
Tel & Fax (401) 846-0655
Antiques, reproductions, accessories
and furniture

SOUTH CAROLINA
The Red Torii
197 King Street
Charleston 29401
(803) 723-0443
Porcelain, *netsuke*, bronzes, cloisonné

TEXAS
*Kimbell Art Museum
3333 Camp Bowie Boulevard
Fort Worth 76107
(817) 332-8451

Loyd-Paxton, Inc.
3636 Maple Avenue, Dallas 75219
(214) 521-1521 / Fax 214-522-4438
Textiles, lacquerware, screens,
porcelain, bronzes, cloisonné

*Metropolitan Museum Gift Shop
Houston Galleria
5015 Westheimer
Houston 77056
(713) 629-1515 / Fax 713-629-1525
Netsuke, lacquer boxes, prints, posters

Oriental Treasures
1322 Slocum Street, Dallas 75207
(214) 760-8888 / Fax 214-749-8888
Some Imari and Satsuma

VIRGINIA
East & Beyond, Ltd.
6727 Curran Street, McLean 22101
(703) 448-8200 / Fax 703-821-1272
E-mail: eandbeyond@aol.com
Tansu, porcelain, kimono, *ranma*,
okimono, obi, decorative objects,
accessories made from obi
www.eandbeyond.com

WASHINGTON
Asia Gallery
1220 First Avenue, Seattle 98101
(206) 622-0516
Wide selection of antiques & furniture,
including baskets, masks, porcelain,
folkcraft, textiles

The Crane Gallery, Inc.
104 West Roy Street, Seattle 98119
(206) 298-9425 / Fax 206-298-9386
Antique Asian art

Glenn Richards
964 Denny Way, Seattle 98109
(206) 287-1877 / Fax 206-287-9025
E-mail: glennri@ix.netcom.com
One-of-a-kind furnishings for gardens and
interiors, antique to contemporary.

Honeychurch Antiques Ltd.
1008 James Street, Seattle 98104
(206) 622-1225 / Fax 206-622-1204
E-mail: hnychrch@ix.netcom.com
Furniture, ceramics, paintings, woodblock
prints, sculptures, stone water basins,
lanterns

Japanese Antiquities Gallery
200 East Boston Street, Seattle 98102
(206) 324-3322 / Fax 206-324-4204
Antique folk art, ceramics, *tansu*, ceramics

Kagedo
520 First Avenue South, Seattle 98104
(206) 467-9077 / Fax 206-467-9518
E-mail: kagedo@kagedo.com
Bronzes, lacquers, *tsuba*, *tansu* and furnish-
ings, architectural carvings, garden stones,
textiles
www.kagedo.com

Lyric Japanese Antiques
8705 5th Avenue, NW, Seattle 98107
Tel & Fax 206-782-4062
E-mail: lyric@lyricjapanese.com
Tansu specialist and wide range of
fine antiques
www.lyricjapanese.com

Andy Shiga's One World Shop
4306 University Way NE, Seattle 98100
(206) 633-2400
Kimono, contemporary ceramics

*Seattle Asian Art Museum
14th E. & E. Prospect, Seattle 98112
(206) 654-3160
Books, gifts, jewelry

Uwajimaya
519 6th Ave. S., Seattle 98104
(206) 624-6248
Books, gifts, jewelry
&
15555 N.E. 24th Street, Bellevue 98007
(206) 747-9012
Washi, shōji lamps, *kimono, noren,
ikebana* vases

CANADA

BRITISH COLUMBIA
Dorian Rae Collection
3151 Granville Street
Vancouver, B.C. V6H 3K1
Tel & Fax (604) 732-6100
Paintings, screens, dolls, ceramics, scrolls

Nikaido Gifts
150-3580 Moncton Street
Richmond, B. C. V7E 3A4
(604) 275-0262 / Fax 604-275-6917
Kimono, obi, accessories, *yukata*, ceramics,
ikebana containers, dolls, lacquerware,
lanterns and wide selection of papers

ONTARIO
From Japan, Inc.
187 Victoria Street
Niagara-on-the-Lake, Ontario L0S 1J0
(905) 468-3151 / Fax 905-468-1697
E-mail : gen500@aol.com
Wide selection of china, handmade
papers, antique woodblock prints,
decorator items, dolls, kimono, textiles

Japanese Canadian Cultural Centre
Box 191, 123 Wynford Drive
Toronto, Ontario M3C 2S2
(416) 441-2345 / Fax 416-441-2347
Gift shop: Ikebana, sumi-e and *origami*
supplies, dishes, dolls, gifts

Japanese Lantern Shop
1126 Tuscarora Street
Windsor, Ontario N9A 3N5
(519) 973-5750
Handmade lanterns, *shōji,
hibachi,* shrines

Japanese Paper Place
887 Queen Street, W.
Toronto, Ontario M6J 1G5
(416) 703-0089 / Fax 416-703-0163
E-mail: washi@interlog.com
Washi of all types, including *shōjigami*
and *chiyogami* (stencilled); origami,
books on paper art

Kamimura Gallery
1300 Bay Street
Toronto M5R3K8
(416) 923-7850
E-mail: kamimura@interlog.com
Specialist in woodblock prints and
paintings. Antique decorative accessories.
www.interlog.com/~kamimura/index.htm

Ki Design
Traditions of Japan
30 Quebec Street
Guelph, Ontario N1H 2T4
Tel & Fax: (519) 837-0038
Specialist and Canadian distributor
of fine cast ironware—teapots, bells, etc.—
plus kimono, ceramics, cookware, *bonsai* &
ikebana supplies. Wholesaler of koi wind-
socks. Art gallery

Okame Japanese Antiques
709 Devonshire Road
Windsor, Ontario N8Y 2L9
(519) 252-6930
E-mail: pepper@mnsi.net
Ceramics, textiles, baskets, scrolls, dolls,
metalwork, woodblock prints, folk art & lac-
quer. Appraisals and restoration, design
consultant

Ozawa Canada Inc.
135 E. Beaver Creek Road, Unit 3
Richmond Hill, Ontario L4B 1E2
(416) 229-6343 or 905-731-5088
Fax 905-731-0778
Tea chests, fine chinaware, kitchen
equipment, housewares, *shōji* screens,
tatami, garden lanterns

Stuart Jackson Gallery
119 Yorkville Avenue
Toronto, Ontario M5R 1C4
(416) 967-9166 / Fax 416-967-6829
E-mail: sj@interlog.com
Specialist in antique woodblock prints.

Things Japanese
159 Harbord St.
Toronto, Ontario M5S 1H1
(416) 967-9797 / Fax 416-440-8964
Antiques including kimono, Imari,
dinnerware, scrolls, *yukata,* cast iron
teapots, bamboo vases

QUEBEC
Gallerie Tansu
1622a Sherbrooke West
Montreal, Quebec H3H 1C9
Tel & Fax (514) 846-1039
Large selection of antiques, including
textiles, kimonos, screens, scrolls, obi

R. Uchiyama
Collection d'Articles Japonais
460 St. Catherine West, Suite 426
Montreal, Quebec H3B 1A7
(514) 363-0596 or 393-1342
Fax 514-595-9161
Garden items including lanterns &
bamboo fencing, home furnishings from
ranma to *shōji* to *tatami,* decorative items,
porcelain, *ikebana* containers,
fabrics, dolls, papers

BIBLIOGRAPHY

Baten L., *Japanese Dolls, The Image and the Motif*
 Shufunotomo, Tokyo, 1986

Blakemore, F., *Japanese Design Through Textile Patterns*
 Weatherhill, New York, Tokyo, 1978

Brandon, R. M., *Country Textiles of Japan, Art of Tsutsugaki*
 Weatherhill, New York, Tokyo, 1986

Clarke, R., *Japanese Antique Furniture*
 Weatherhill, New York, Tokyo, 1983

Condon, C. and Nagasawa, K., *Kites, Crackers and Craftsmen*
 Shufunotomo, Tokyo, 1973

Dower, J. W., *The Elements of Japanese Design*
 Weatherhill, New York, Tokyo, 1971

Fujita Hotel, Ltd., *We Japanese*
 Yamagata Press, Tokyo, 1950

Hauge, V. and T., *Folk Traditions in Japanese Art*
 Kodansha International, Tokyo, New York, 1978

Hughes, S., *Washi, The World of Japanese Paper*
 Kodansha International, Tokyo, New York, 1978

Ito. T., *Tsujigahana, The Flower of Japanese Textile Art*
 Kodansha International, Tokyo, New York, 1985

Kawashima, C., *Minka, Traditional Houses of Rural Japan*
 Kodansha International, Tokyo, New York, 1986

Koizumi, K., *Traditional Japanese Furniture*
 Kodansha International, Tokyo, New York, 1986

Lee, S. E., *The Genius of Japanese Design*
 Kodansha International, Tokyo, New York, 1981

Lowe, J., *Japanese Crafts*
 Van Nostrand Reinhold Company, New York, 1983

Mizoguchi, S., *Arts of Japan 1, Design Motifs*
 Weatherhill, New York, Tokyo, 1973

Morse, E. S., *Japanese Homes and Their Surroundings*
 Charles E. Tuttle Co., Rutland, Vermont and Tokyo, 1972

Munsterberg, H., *The Folk Arts of Japan*
 Charles E. Tuttle Co., Rutland, Vermont and Tokyo, 1958

Muraoka, K. and Okamura, K., *Folk Arts and Crafts of Japan*
 Weatherhill, New York and Heibonsha, Tokyo, 1967

Nagatake, T., *Imari*
 Kodansha International, Tokyo, New York, 1982

Saint-Gilles, A., *Mingei, Japan's Enduring Folk Arts*
 Amaury Saint-Gilles, 1983

Salmon, P., *Japanese Antiques*
 Art International Publishers, Tokyo, 1975
Tsuchiya, Y., *A Feast for the Eyes, Japanese Art of Food Arrangement*
 Kodansha International, Tokyo, New York, 1985

Wada, Y., Rice, M. K., Barton, J., *Shibori, The Inventive Art of Japanese
 Shaped Resist Dyeing*, Kodansha International, Tokyo, New York, 1983

Yagi, K., *A Japanese Touch for Your Home*
 Kodansha International, Tokyo, New York, 1982

Yanagi, S., *The Unknown Craftsman*, Adapted by Bernard Leach
 Kodansha International, Tokyo, New York, 1972

Yamanaka, N., *The Book of Kimono*
 Kodansha International, Tokyo, New York, 1982

Yamanaka, N., *Kimono and the Spiritual Culture of Japan*
 Mainichi News, Tokyo, 1980

Yamanobe, T., *Opulence, The Kimonos and Robes of Itchiku Kubota*
 Kodansha International, Tokyo, New York, 1984

Discover Japan, Volumes 1 and 2
 Kodansha International, Tokyo, New York, 1983

Kodansha Encyclopedia of Japan
 Kodansha, Tokyo, 1983

Zenkoku Komingu Kotto Nomi-no-ichi Annai
 Kogei Shuppan, Tokyo, 1984

INDEX